DIGITAL PHOTOGRAPHER'S NEW GUIDE TO PHOTOSHOP PLUG-INS

Editor: Matt Paden
Co-author and Technical Editor: Scott Stulberg
Book Design: Sandy Knight, Hoopskirt Studio
Cover Design: Thom Gaines, Electron Graphics

Library of Congress Cataloging-in-Publication Data

Zuckerman, Jim.
 Digital photographer's new guide to Photoshop plug-ins / Jim Zuckerman,
Scott Stulberg.
 p. cm.
 Includes index.
 ISBN 978-1-60059-212-6 (pbk. : alk. paper)
 1. Computer graphics. 2. Adobe Photoshop. 3. Plug-ins (Computer
programs) I. Stulberg, Scott. II. Title. III. Title: New guide to Photoshop
plug-ins.
 T385.Z84 2009
 006.6'86–dc22

 2008038986

10 9 8 7 6 5 4 3 2

Published by Lark Books, A Division of
Sterling Publishing Co., Inc.
387 Park Avenue South, New York, N.Y. 10016

Distributed in Canada by Sterling Publishing,
c/o Canadian Manda Group, 165 Dufferin Street
Toronto, Ontario, Canada M6K 3H6

Distributed in the United Kingdom by GMC Distribution Services,
Castle Place, 166 High Street, Lewes, East Sussex, England BN7 1XU

Distributed in Australia by Capricorn Link (Australia) Pty Ltd.,
P.O. Box 704, Windsor, NSW 2756 Australia

If you have questions or comments about this book, please contact:
Lark Books
67 Broadway
Asheville, NC 28801
(828) 253-0467

Manufactured in China

ISBN: 978-1-60059-212-6

For information about custom editions, special sales, premium and corporate purchases, please contact Sterling Special Sales Department
at 800-805-5489 or specialsales@sterlingpub.com.

DIGITAL PHOTOGRAPHER'S NEW GUIDE TO

PHOTOSHOP PLUG-INS

JIM ZUCKERMAN & SCOTT STULBERG

LARK BOOKS

A Division of
Sterling Publishing Co., Inc.
New York / London

DIGITAL PHOTOGRAPHER'S NEW GUIDE TO
PHOTOSHOP PLUG-INS

1

DÉJÀ VU · 16

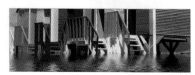

2

WALK ON THE WILD SIDE · 48

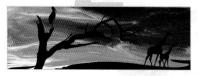

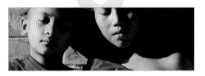

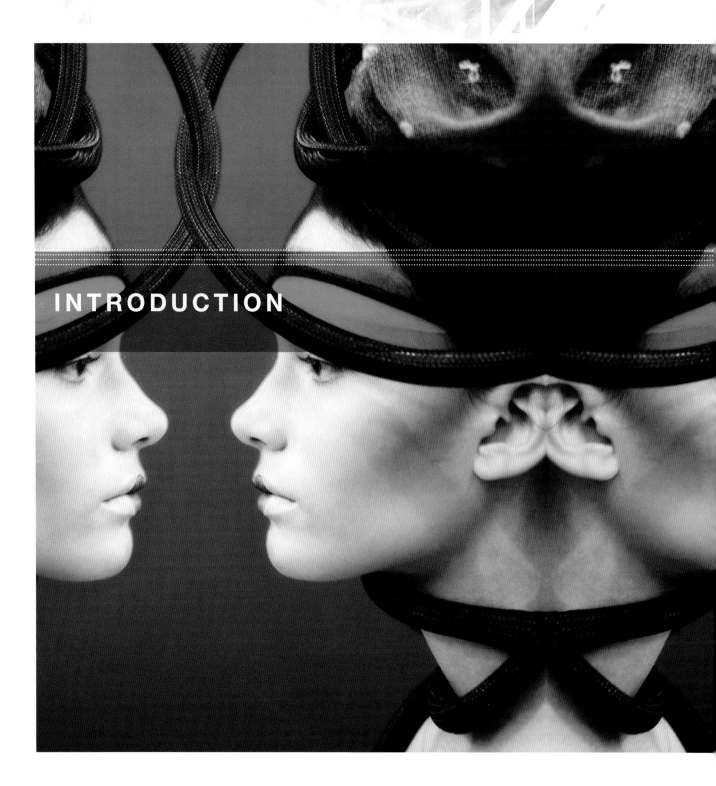

INTRODUCTION

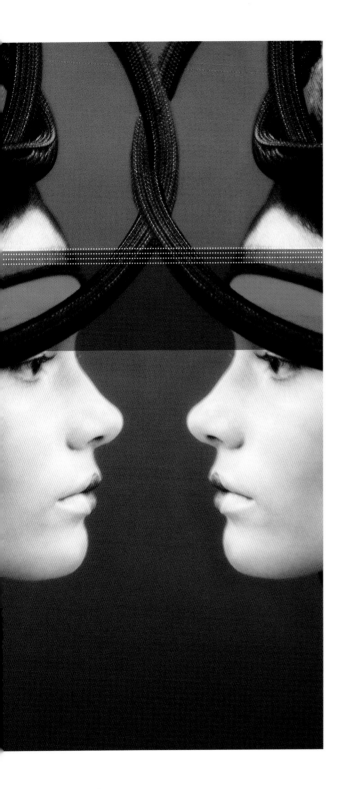

Whether you're a photographer who is new to Photoshop or you are a seasoned pro, using plug-ins will add dimensionality to your work and simplify your workflow. Sure, Photoshop comes with a pretty decent standard set of filters that can manipulate and modify your images, but by using third-party plug-ins, you can easily achieve some really stunning effects that would be impossible to do in Photoshop alone. Simply put, using plug-ins will make altering or fixing your pictures in Photoshop easier and give you options that will add new creative elements to your work.

Plug-in filters have been part of Photoshop's arsenal of tools since the beginning, when Adobe included many specialized filters to fix and enhance images or add a variety of creative effects. Software vendors followed suit and decided to design some of their own Photoshop plug-ins to give users even more options. These filters became known as third-party plug-ins and offer an amazing variety of looks and effects.

Our purpose in writing this book was to compile the most exciting plug-in filters available for Photoshop and Photoshop Elements in one place. There are many plug-ins on the market that duplicate effects that can already be achieved in Photoshop, that offer technical updates like RAW converters, or that add various colors and tones to images similar to how photographic filters work, but we have not included those options here. We want to illustrate only the best tools that will truly expand your creativity and workflow in the digital realm.

Plug-ins have a variety of uses; some of the effects we demonstrate are beautiful, some enable you to turn your photographs into fine art, some are enhancements that make good photographs better, and others can only be described as surreal. Many of these filters will open new doors for you and stretch your artistry beyond what you imagined possible. Just flip through the pages of this book and look at the altered pictures to get an idea of the countless ways your photographs can be changed, smoothed, de-noised, mirrored, liquified, focused, painted, solarized, merged, framed, and more.

As you begin to apply plug-ins to your photos, keep in mind that not all images look good with any given filter. The first part of the creative plug-in process is choosing pictures that translate well. Usually, simplicity of design is a good place to start while searching through your photo library. If you work with an image that is very busy or if there are distracting elements behind your subject, you may be disappointed with the results. It is also a good idea to avoid patchy lighting and blown highlights in your shots. Using these simple guidelines will help you select photographs that will most likely look great with more than one plug-in filter.

It is not necessary to purchase the plug-ins described in this book to experiment with them. Most of the plug-ins covered here have free trial versions available that last 15 or 30 days. Sometimes these trials won't allow you to save the manipulated image or they put a watermark on the final photo, but most often you can use the software without any problems. This way, you can see if you like the effects a plug-in creates before you buy the product.

After you experiment with the creative techniques we describe in the following chapters, you will be on your way to producing a whole new generation of photos that will make you proud of your work—and best of all, they will be a lot of fun to create.

HOW TO USE THIS BOOK

You'll get the most out of the information in this book if you download the trial software before you begin reading about each plug-in. That way, as you read, you can follow the descriptions and learn the program in a step-by-step fashion. Use your own pictures and feel free to stray from the text and experiment as you go along—often, it's the best way to learn new software. A book of this nature is like a map; it can be a great guide, but as with driving in an unfamiliar town, you won't really know your way around until you explore in person.

Need to Know

Each plug-in has an informational section called Need to Know. This will tell you the website where you can find the trial software, and any notes that are good to be aware of before you get started. There is also a price range offered for each plug-in that is organized as follows:

●○○○○	$0–$50
●●○○○	$51–$100
●●●○○	$101–$150
●●●●○	$151–$200
●●●●●	$201–$250
●●●●● +	$250 or more

Installing and Accessing Plug-ins

Plug-in filters go into the Plug-ins folder within Photoshop. Commonly, when you download the software (either a trial or the licensed version) it automatically installs into the Plug-ins folder when you follow a series of steps in the installation software that automatically appears. Occasionally you may have to place a plug-in into the folder manually or you may need to make sure it is correctly installed. To do this, open the Photoshop folder in your Applications folder (Mac) or Program Files (PC) and you will find the Plug-ins folder. Open it, and you can either place a plug-in into it or verify that one is there. Once you install a plug-in, Photoshop has to be quit and reopened for the plug-in to be recognized. The new filter will be seen in the Filter pull-down menu somewhere near the bottom of the list.

Some of the programs in this book, like Photomatix, aren't plug-ins and act like stand-alone programs. This means they work independently of Photoshop and install directly into your Applications or Program Files folder. When you are done modifying your image in these programs, save the file and reopen it in Photoshop if you want to make other changes.

AN INTRODUCTION TO LAYER MASKS

P hotoshop has many powerful tools and features built into it, and without a doubt the most powerful one would have to be the ability to create floating layers. Layers allow us to apply a wide range of effects to our images without affecting the original picture. Layers can also be turned off at any time to hide any changes that have been made on them. However, making changes on a layer often affects the entire image, especially when applying many of the filters in this book, and sometimes we only want part of our image to be changed. That's where a layer mask, the best-kept secret in Photoshop, comes in. Creating and using a layer mask lets you selectively show or hide an effect or technique anywhere in the image. For example, instead of having your entire image blurred from a Gaussian Blur, you can apply the blur to just a specific part (or parts) of the image.

It's important to cover the topic of layer masks at the beginning of this book because they will let you apply the plug-in filters with a much greater amount of control. You can be as specific as you want in affecting the photograph, and you can tweak your work at any time without altering the original picture.

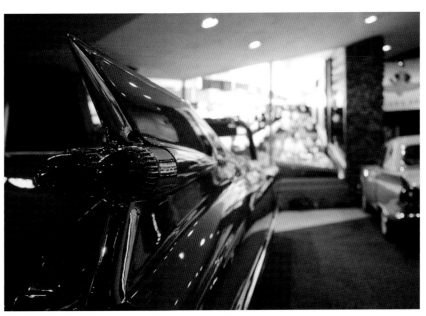

PHOTO A
By using a layer mask, I will be able to enhance the color of this car's paint with a plug-in and still preserve the rest of the image's original appearance.

WORKING WITH LAYER MASKS

To begin using layer masks, open Photoshop and select a picture. For my example, I'll be using a photo of the Cadillac seen in **PHOTO A**. Throughout this book, we'll be using our own images to show the steps involved for working with the many plug-ins this book covers. And while our pictures obviously won't be the same as yours, you can follow along on your own images. Just remember that settings we use won't always work exactly the same on your images. You'll often have to experiment to find settings that work for your pictures, which is a good thing. The creative nature of plug-ins makes them perfect for experimentation.

In my original picture of the Cadillac, I wanted to enhance the color of the red body paint since color always has a tremendous influence on the impact an image makes. The first step in the layer mask process is to create a duplicate layer from the original layer. There are several ways to do this in Photoshop, but the easiest is to go to the pull-down menu and choose Layer>Duplicate Layer **(FIGURE 1).** This creates a background copy layer as seen in **FIGURE 2.**

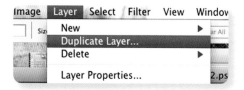

FIGURE 1

Now that I have created a layer copy, I can apply any effect or technique that I want to this image. (Just always be sure that you're working on the duplicate layer by opening the Layers palette and noting that the duplicate layer is highlighted.) For this example, I used one of the plug-in filters that is discussed later in this book, Nik Color Efex Pro (see page 63). I chose their Bleach Bypass Filter and changed its settings in the dialog box until I got the paint color on the Cadillac looking just the way I wanted. The rest of the image looks blown out to me, but it doesn't matter since using layer masks will apply the filter effect to just the Cadillac when I'm done. I hit OK to apply the filter to my duplicate layer. My entire image now has the Bleach Bypass effect applied to it **(PHOTO B),** and I can start using the layer mask so only the Cadillac is affected.

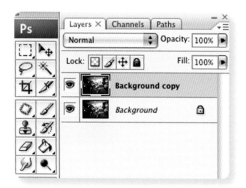

FIGURE 2

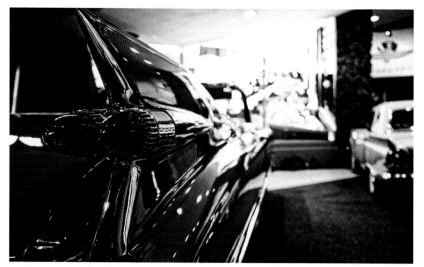

PHOTO B

While the Bleach Bypass filter has increased the color saturation on the car, it has had a negative impact on the rest of this image. Using a layer mask will show the filter's effect only in the areas I select.

There are two ways to apply a layer mask. They are called Hide All or Reveal All, and they essentially let you paint in or paint out the filter's effect with Photoshop's Brush tool. To create a layer mask using Hide All, which is the choice I usually use, go to the pull-down menu and chose Layer>Layer Mask>Hide All **(FIGURE 3).** This basically hides (or masks) the effect that I just created using the plug-in filter. Now I'm ready to use the Brush tool to paint in the filter to reveal the brighter looking red color for the Cadillac.

In the Layers palette, you can now see there is an icon filled with black on the Background Copy layer **(FIGURE 4).** This icon represents my layer mask and it is filled with black because I chose Hide All. Since this layer mask icon is black, I need to make sure that my foreground color swatch on the bottom of the Tools palette is white. If my layer mask were white (which it would be if I chose Layer>Layer mask>Reveal all), then the foreground color would need to be black. With white selected as my foreground color, I went to the Tools palette and choose the Brush tool.

I'm now ready to begin painting back in the effect from the plug-in filter. I chose my brush size with the bracket keys on my keyboard (the left bracket key makes the brush smaller and the right bracket key makes it larger) and began painting back in the effect on the Cadillac. My preferred way to use any of the brush tools in Photoshop is to use a Wacom graphics tablet. Instead of using a mouse to paint in my effects, which is not a very natural way to paint, a Wacom tablet uses a stylus (a cordless pen) that feels much more comfortable. Once you use a graphics tablet, especially when working with the Brush tool, you can never go back to only using a mouse.

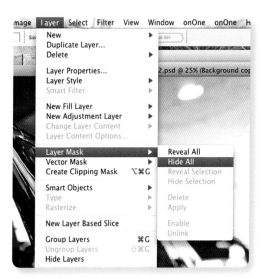

FIGURE 3

There are two types of layer masks: Reveal All and Hide All, and these can be selected under the Layer Mask menu. I chose Hide All for this example.

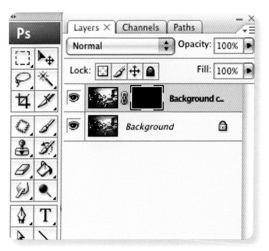

FIGURE 4

Once a layer mask has been applied to an image, it will appear as a new layer in the Layers palette. The black square icon on the layer represents the mask.

With a small brush size selected, I began to paint in my effect over the Cadillac with the brush tool. In **FIGURE 5,** you can see that the circled area is lighter and more saturated in color than the surrounding area. This shows the Bleach Bypass layer coming through as the mask is painted away. I chose a smaller brush to work in tight areas of the image, and then I made the brush size bigger for painting along the broad sides of the Cadillac. In this situation, I made sure to keep the brush inside the lines of the Cadillac so as to not affect the background. Depending on the image, I may work from 100–300% magnification so the application of the effect is absolutely precise.

If you accidentally paint the effect outside of the area that you want, it's very easy to fix. Just change the white foreground color to black and this will let you paint out the effect where it's not wanted.

When I am done, the effect of the plug-in filter has been selectively applied to the red Cadillac and to no other part of the image **(PHOTO C).** Using a layer mask is a key step to improving your Photoshop skills. Once you start using layer masks in your images, you will wonder how you ever worked in Photoshop without them.

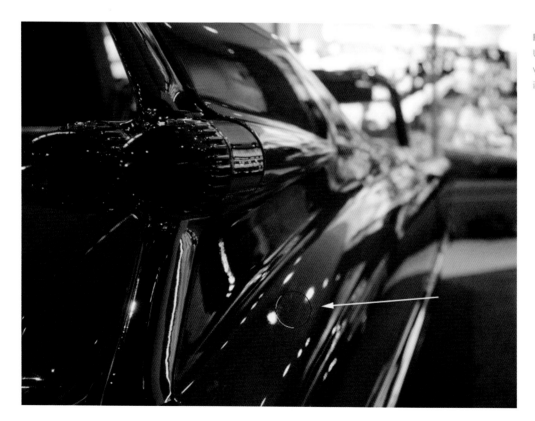

FIGURE 5
Use the Brush tool at various sizes to paint in the filter's effect.

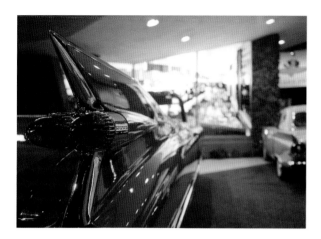

The original image {LEFT} looks dull compared to the finished product seen below {PHOTO C}. By using a layer mask, I was able to pump up the color on the car and keep the picture's background the same as it originally appeared.

PHOTO C

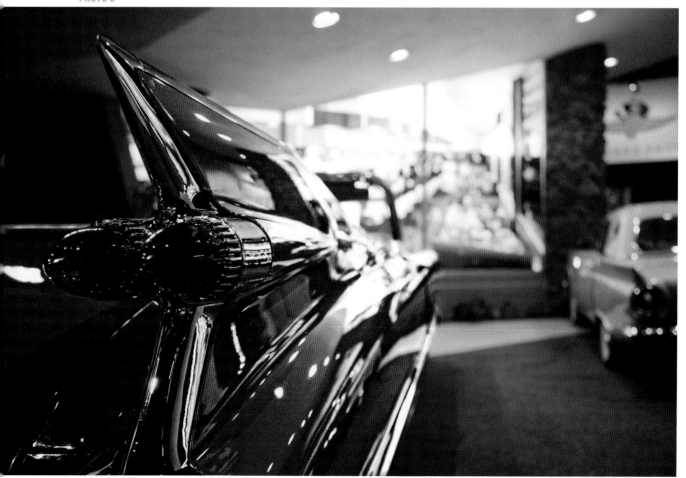

CHAPTER ONE

Instant Mirror, p18 Flood, p28 Photomatix, p36

DÉJÀ VU

The plug-ins in this chapter invite you to revisit many of your photographs and look at them with fresh eyes and an open mind. In other words, experience déjà vu and really see into some of your photos for the first time. Once you see what the software in this chapter can do, you will begin to realize the countless possibilities for embellishing what you have already captured as well as creating completely new images that have little resemblance to their originals.

Instant Mirror gives you the ability to duplicate portions of your images as if you are seeing them reflected. You can position the "mirrors" at different angles in an image to create wild interpretations. Sometimes surreal, and always eye-catching, Instant Mirror images always makes viewers take notice...and then look again.

Flood is one of my favorite plug-ins because it can create bodies of water that realistically simulate a lake or pond. Subjects in your photos are naturally reflected in the water's surface, allowing for almost any image to become an interesting, watery abstraction.

The days of unintended high contrast images are coming to an end, thanks to Photomatix. This program has revolutionized photographers' ability to expose correctly for a wide range of light and dark tones in one image. Photomatix creates images with high dynamic range (HDR), which means the photo of a scene or subject looks similar to the way our eyes and brain naturally interpret it. Photographers can now capture detail in the darkest of shadows and the brightest of highlights in a series of photographs and merge them into a single correctly-exposed HDR photograph.

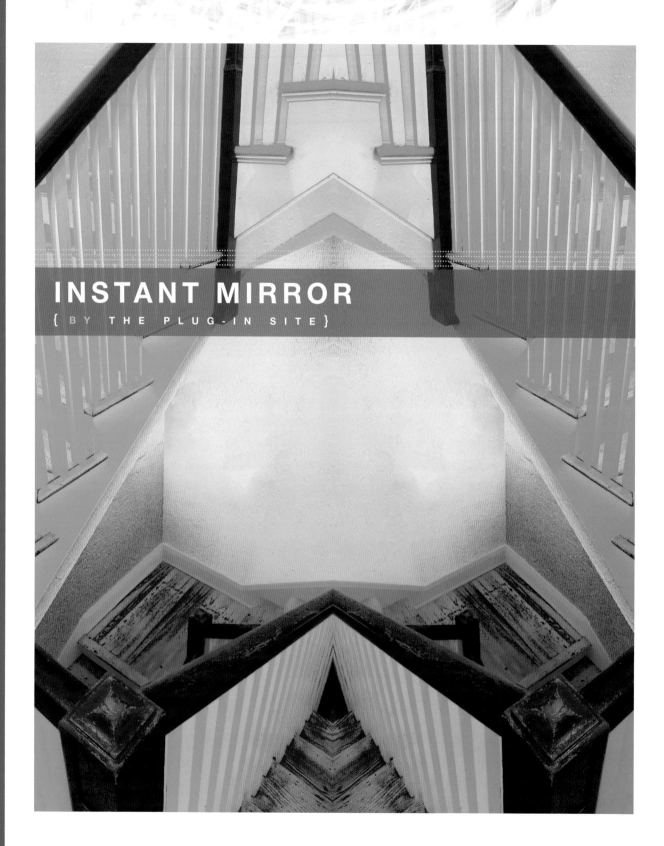

INSTANT MIRROR

{ BY THE PLUG-IN SITE }

nstant Mirror goes beyond what Photoshop can do with respect to mirroring an image, and it does it instantly without the necessity of going through several laborious steps. In addition, Instant Mirror can create unique angles, reminiscent of kaleidoscopes, where sections of an image are reflected in ways that would be virtually impossible to create using only Photoshop. This plug-in's easy-to-use dialog box has a preview window where you can see the options that allow you to transform any photograph into a striking surreal image or geometric graphic design.

NEED TO KNOW

Website: thepluginsite.com

Price Range: $ ○○○○

Notes: A free trial version of the software can be downloaded from the company's website. Instant Mirror is sold as part of a bundle called Plugin Galaxy that includes 21 other plug-ins.

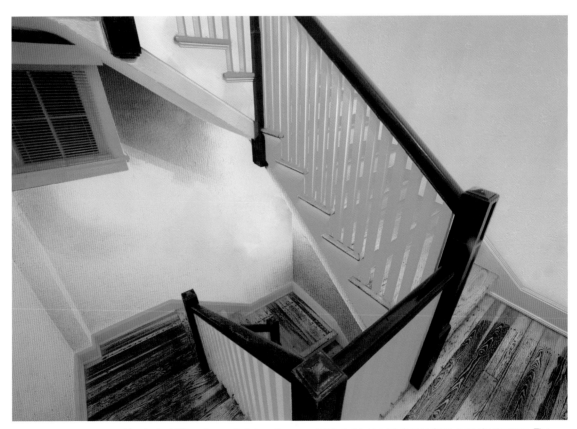

Use Instant Mirror to create interesting geometric patterns and shapes from everyday images. The original picture of a staircase in a Florida hotel **(ABOVE)**, became an eye-catching abstraction **(LEFT)** once Instant Mirror was applied.

USING INSTANT MIRROR

There is only one control in this filter's dialog box that gives you access to the creativity in Instant Mirror. In **FIGURE 1,** the red arrow is pointing to the pull-down menu that, when clicked, reveals 12 different ways in which you can mirror a photo. The two choices that I find produce the best results are Vertical Right and Vertical Left. The former makes the right edge the center of the manipulated image, and the latter does the same with the left edge. The results are very different, as you can see in **PHOTOS A** and **B.** I began with the same original photo, yet the two mirror renditions create very different results.

It is not obvious from looking at the dialog box, but if you hold down the Control key, you can click and drag the image in the preview window and it will re-establish the center point for the mirror effect. This creates a completely unique variation that you can see in **PHOTO C.** This shows just one of many possibilities available as you move the cursor over the preview window, rearranging the elements in the original photo.

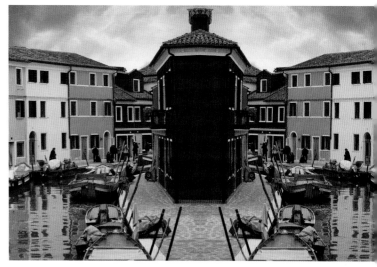

PHOTO A

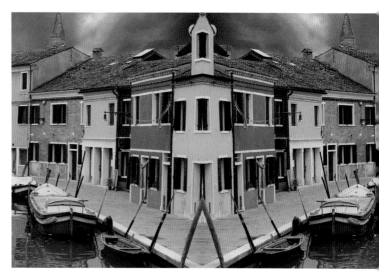

PHOTO B
The top image **(PHOTO A)** was created by using Vertical Right while **PHOTO B** was made by selecting Vertical Left from the pull-down menu.

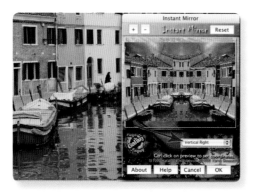

FIGURE 1
Use the pull-down menu in the Instant Mirror dialog box to select how you want to mirror an image.

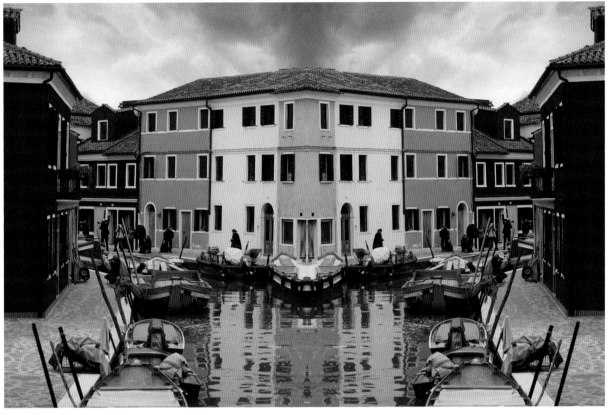

PHOTO C

To create your own point that the software should mirror from, hold down the Control key and click anywhere in the image. Wherever you select will become the center point for the mirror effect.

Almost every image you have in your files can work successfully with this plug-in, from busy, complex photos to ones that exhibit simplicity of composition. Even portraits of people work, although the results are often bizarre (see page 23). In virtually all cases, what you create is a total surprise. It's very hard to look at an original photo and imagine it as a mirror, and the surprise is part of the appeal with using this plug-in.

Note: *If you have layers in your image, you must use the command* **Layer>Flatten Image** *before applying Instant Mirror. Otherwise, the filter will not work on the entire photo; it will only mirror the layer that is selected at the time you apply the technique. If you don't want to lose your layers, then I suggest you make a copy of the image to use before the plug-in is applied. Flatten the layers in the copy and use it as your experimental version.*

These examples of the
Vertical Right and Vertical
Left options were created
from **PHOTO D** of the Cinque
Terre coast in Italy, which
produced **PHOTOS E** and **F.**

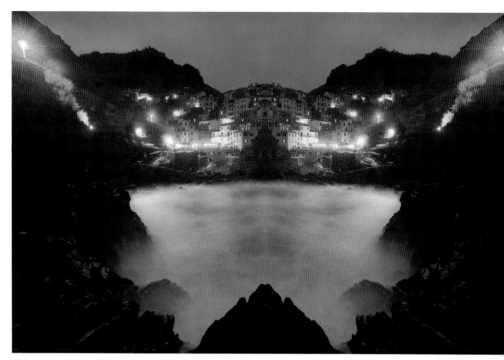

PHOTO D

PHOTO E
Vertical Right

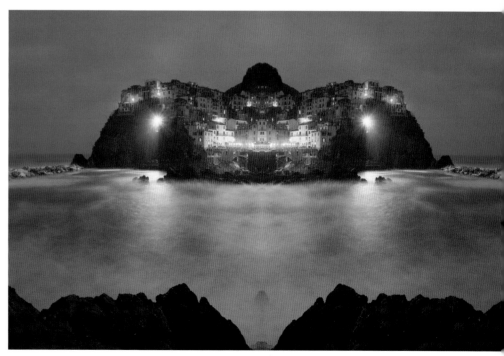

PHOTO F
Vertical Left

MIRRORING PEOPLE

I tried mirroring my son, Reynold, using
PHOTO I. The whimsical (and bizarre) mirrored
rendition in **PHOTO J** made him laugh when he saw
it, but I didn't like the crossed eyes so I replaced
PHOTO I with a forward-looking shot of him, and
the result is **PHOTO K.** To make the eyes look more
natural, I selected one eye with the Lasso tool
and copied it to the clipboard (Edit>Copy). Then I
pasted it into the mirrored image twice and used
Edit>Transform>Flip Horizontal on one of them.
With the Move tool, I placed the eyes where I
wanted them and then used the Healing Brush to
blend the edges into the background.

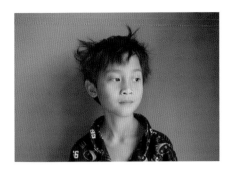

PHOTO I

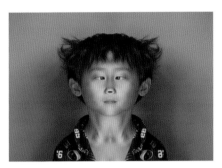

PHOTO J

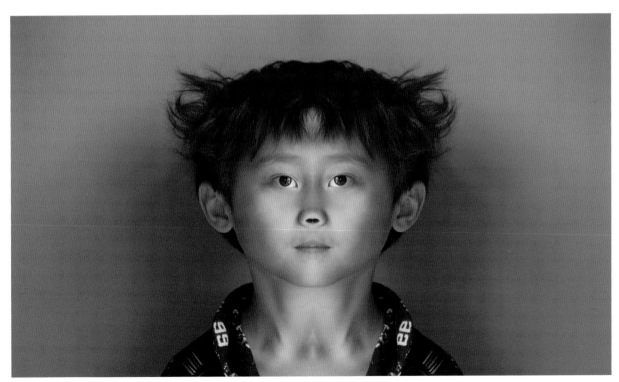

PHOTO K
Mirroring people will always give strange results. Try using a picture of your subject looking straight
at the camera to get the best look possible.

23

BEYOND VERTICAL LEFT AND VERTICAL RIGHT

The other options in the pull-down menu affect your photos in a variety of ways. The four Quadrant filters mirror the top and bottom and both sides of an image at the same time, and the possibilities are intriguing as you can see in **PHOTO L** (the original), and its two derivatives, **PHOTOS M** and **N.** The four Crossing filters mirror the photo on a diagonal angle, simulating a kaleidoscope but with much more control as to how the elements from the original are arranged.

PHOTO L

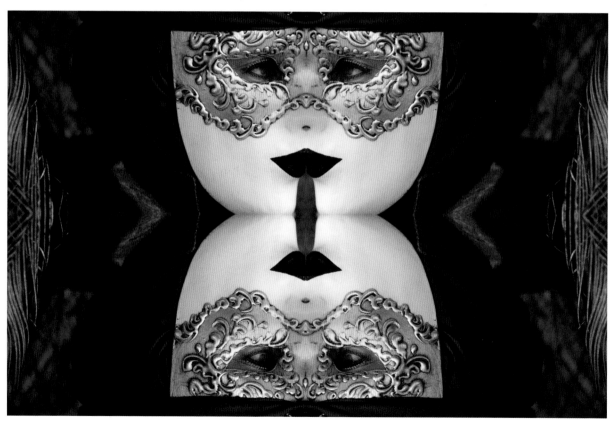

PHOTO M

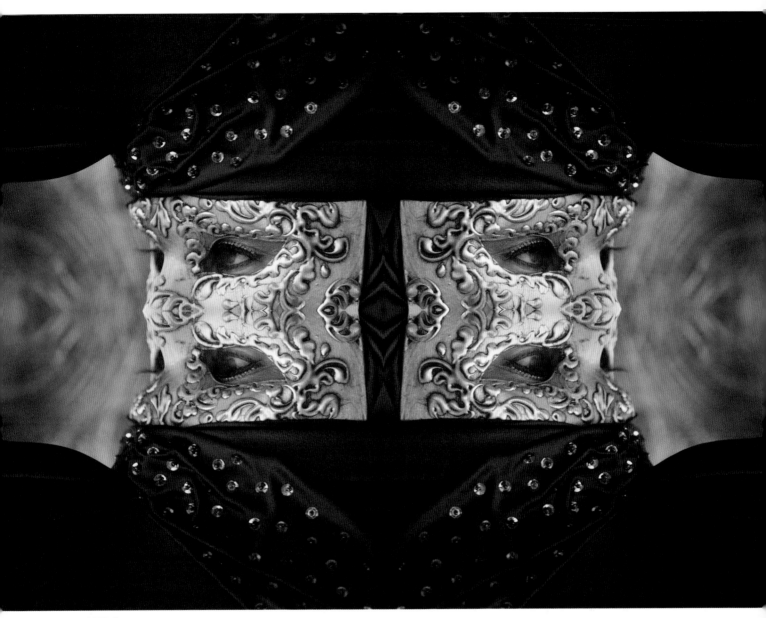

PHOTO N

Don't feel like you have to stick to the Vertical Left and Vertical Right options. Using the Quadrant or Crossing filters will create fun and unexpected results, some with kaleidoscopic effects.

In **PHOTO O,** I applied Horizontal Right to a photo I took in Ireland, and then used Crossing Top to create **PHOTO P.** The kinds of photos that work well with this technique are those that have strong graphic lines and good contrast. Choose pictures where the lines are very pronounced and the colors are strong enough so they emphasize the graphic style of the images.

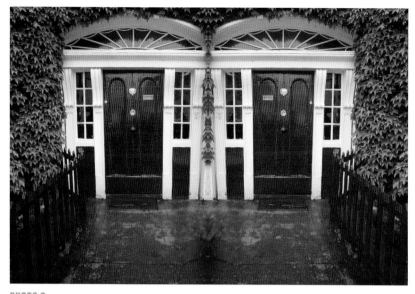

PHOTO O

Try applying mirrors to an image more than once, as I have done with **PHOTOS O** and **P,** to see if an interesting graphic emerges.

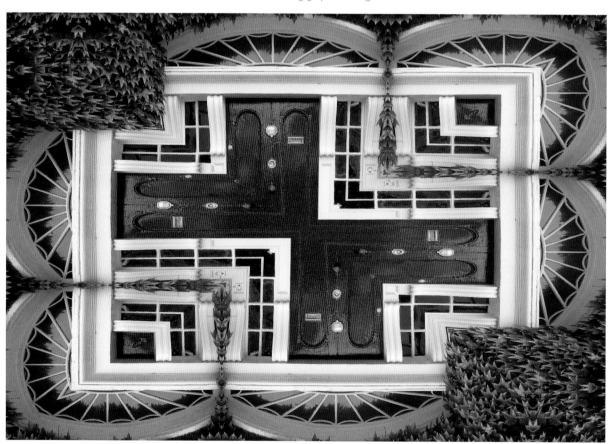

PHOTO P

THE DOUBLE TAKE

One of the techniques I like to use when I mirror images is to add (or subtract) another element after I've mirrored the original photo. For example, in **PHOTO Q,** I mirrored the tree in a snowy meadow using the Horizontal Right filter, and then placed the wolf in the picture using cut and paste in Photoshop. Since the animal isn't mirrored, it seems that this image may not be a manipulation at first glance; however, the perfection of the trees' symmetry eventually forces one to conclude otherwise. Adding asymmetry gives people pause and makes your mirrored images more intriguing. I did the same thing with **PHOTO R,** where the picture of clouds taken from an airplane was mirrored, and the flock of Canadian geese was then placed between them.

In the photo of the uniquely styled Florida beach chairs in **PHOTO S,** I mirrored a palm tree and the chair-backs, but used Photoshop to replace the sky. I used a straight, un-mirrored shot of clouds, giving the impression that there was no manipulation. Only the identical palm tree on both sides of the frame gives away what I did. It would be quite possible to have identical chairs lined up like this, but the two palms couldn't be exactly the same.

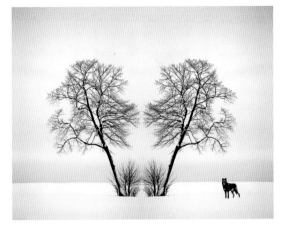

PHOTO Q

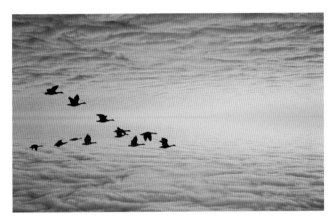

PHOTO R

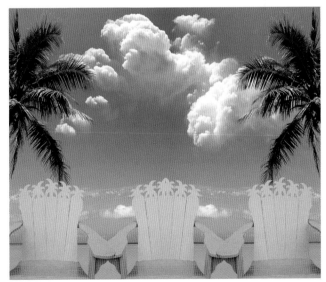

PHOTO S

27

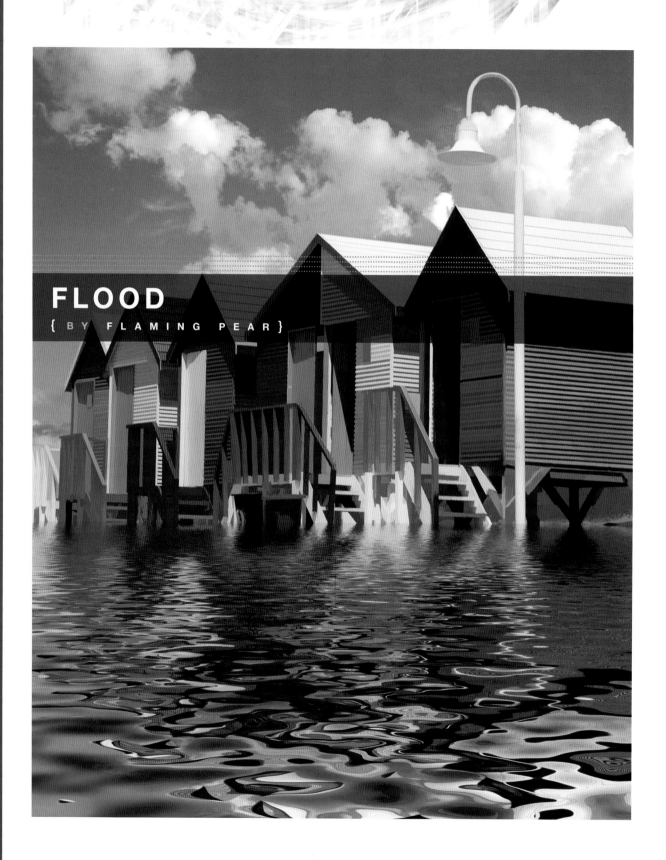

FLOOD
{ BY FLAMING PEAR }

One of my favorite filters in the pantheon of Photoshop plug-ins is Flood, which creates watery surfaces and reflections that are very realistic. In fact, the reflections that are generated are much more believable than the Wave filter native to Photoshop. Initially, it's easy to think about ponds and lakes reflecting a distant shoreline of trees, a mountain range, or a city skyline, but this fantastic plug-in can be used for a surprisingly diverse number of subjects, as we'll soon see.

NEED TO KNOW

Website: flamingpear.com

Price Range: $ ◯ ◯ ◯ ◯

Notes: A free trial version of the software can be downloaded from the company's website. Flood can be purchased individually, or it can be bought in various bundled software packages for a variety of prices.

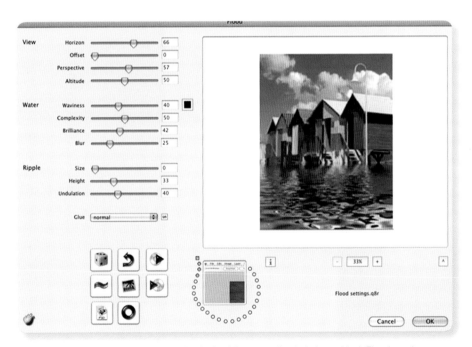

With many sliders available to control the look of the water that is being added, Flood can be very customized to match almost any scene.

ESTABLISHING THE HORIZON

Before you can begin manipulating the digital body of water, you must first establish a horizon line in the image. To get started, open Photoshop and choose a picture into which you'd like to add a waterscape. Then open the Flood plug-in and use the first slider bar (labeled Horizon) in the dialog box to create a horizon line anywhere in the photo. Using the original photo of a sand dune I shot in Namibia as an example **(PHOTO A),** I created two very different reflections. Compare **PHOTOS B** and **C** and notice where I placed the horizon line. In **PHOTO B,** I completely eliminated the tree, while in **PHOTO C** I chose to include not only the tree, but some of the desert scrub as well. **FIGURES 1** and **2** show the position of the sliders to illustrate how I set the Horizon for photos B and C. The large preview in the dialog box displays how the image will be affected as you move the horizon up or down.

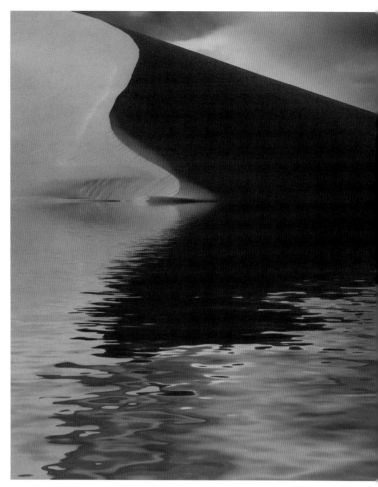

PHOTO B

The first step in Flood is to decide where you want to establish the Horizon line. Do you want to cover a lot of the image **(PHOTO B)**, or leave in some of the scene's other elements **(PHOTO C)**?

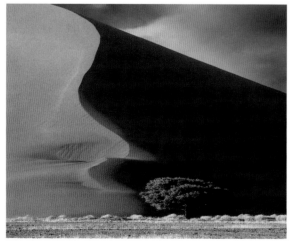

PHOTO A

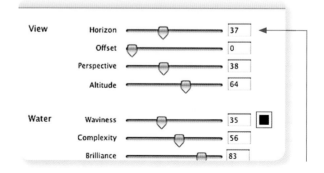

FIGURE 1

Use the Horizon slider to specify how much of the image will be covered in water. For **PHOTO B**, the slider was set to 37.

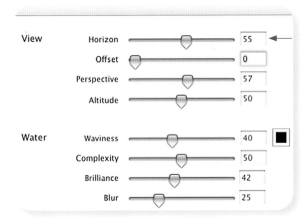

Making Space

Notice that in both **PHOTOS B** and **C,** I began with an original horizontal image and ended up with a vertical one. Though it's not always necessary, you may often find that you want to extend the canvas to allow more image area for the water. This can be thought of as adding real estate to the image. To add space, go to Image>Canvas size; a dialog box will appear.

Using the tic-tac-toe-like graphic (**FIGURE 3**), decide where you want the additional space to appear. The gray square in the middle of the graphic represents the photo. In this example, I clicked in the upper-middle square and that moved the gray box to that spot. This means that the new "real estate" will be added below the photo, as shown by the arrows. If you were to move the gray box to the middle-right box, then the new area would be added to the left side. Type the amount of the enlargement desired into the appropriate fields. Also note the background-color pull-down menu; this specifies what color you will see in the expanded portion of the image. It doesn't matter what color you choose in this case because the water will soon cover it.

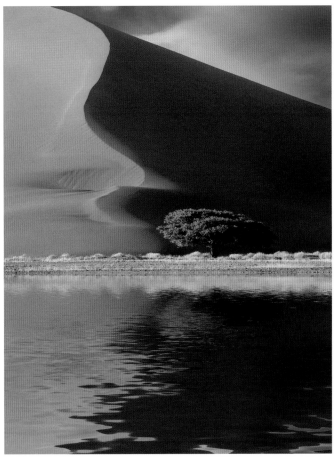

PHOTO C

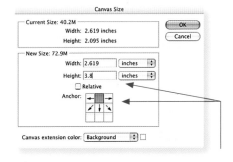

FIGURE 3
By changing the canvas size in Photoshop, you can create more image area for Flood to cover in water.

CREATING WAVES

In the Flood dialog box, the four sliders most commonly used to create an infinite number of wave patterns are those found under the Water section: Waviness, Complexity, Brilliance, Blur. They are used in conjunction with each other, and most of this plug-in's creative effects are altered by working these four controls until you are satisfied with the reflection's appearance. There is no "correct" setting that will give you a guaranteed-perfect reflection because every photo is different and each reflection has to be customized for the subject. Image resolution also makes a difference. A wave pattern on a 40MB file will look very different if the same parameters are used on a 5MB file.

Not all bodies of water require waves. Waves are more common on large bodies of water, so if you are creating what looks like a pond or even something smaller, waves may not be appropriate. For example, I created a reflection in front of a Red Lechwe in Botswana (PHOTO D), and it just didn't make sense to me that a body of water this small would have waves. It might have small ripples, but nothing more. FIGURE 4 shows where the sliders were positioned to create the image seen in PHOTO D.

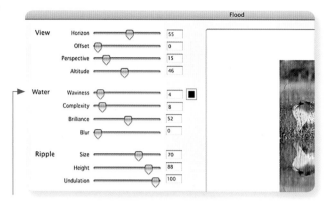

FIGURE 4

Use the Water controls to specify how calm or broken the water's surface will appear in the image. The settings used here created the flat, placid water seen in **PHOTO D.**

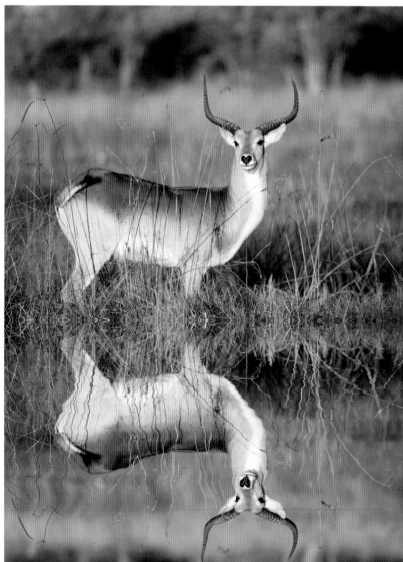

PHOTO D

Ripples

The three sliders at the bottom of the dialog box under the Ripple section (SEE FIGURE 5) are much more realistic than the Pond Ripples offered in Photoshop (which can be found under Filter>Distort>Zigzag, if you'd like to compare). I've never been happy with Photoshop's attempt to create realistic ripples; however, the effect in Flood is subtle and believable. Using a combination of the three ripple controls, I created a credible disturbance in the water at the base of the elephant seen in PHOTOS E-G. In PHOTO E, there are no ripples and the image looks oversimplified, while in PHOTO F I applied some ripples and the water around the elephant's feet is now broken up and looks much more natural. In PHOTO G, I've cropped tightly in on the water to show that the effect looks like believable ripples on the surface of the water.

The Glue pull-down menu found beneath the Ripples section is like the blend modes in Photoshop. I've never found a good use for any of these effects in creating realistic, or even surrealistic, reflections. But it is interesting to experiment with them for different visual effects.

PHOTO E

PHOTO F

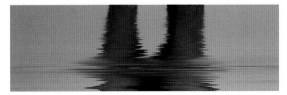

PHOTO G

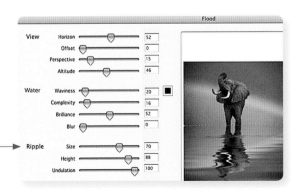

FIGURE 5
Use the sliders under the Ripple section to apply realistic disturbances to the water's surface.

EXTRA OPTIONS

A number of extra controls can be found at the bottom of the Flood dialog box, which appear as icon buttons. The first, which looks like a die, is Randomize. Every time you click this, it's like a roll of the dice—all the parameters are changed and the wave pattern displays endless variations in the preview window. If you don't really know what kind of wave pattern is appropriate for your picture, this will give you a continual slideshow of possibilities.

Just below the die, the Random Seed icon **(FIGURE 6)** changes the wave pattern, but retains the position of all the sliders. Once you have established the surface of the water in a way that looks good to you, try this button and study the various options it offers up. The other icons grouped here don't offer image-altering effects; instead, they offer other controls like Save and Undo. If you let the cursor hover over these icons, a small text box will appear telling you what they do.

Below the image preview there is a strange horseshoe-shaped configuration of small circles. These are program presets, and by clicking in any of the open (non-colored) circles you can save the specific wave pattern you've just created. This acts as a shortcut almost, because later all you need to do is click on the circle where you saved the preset and its settings are loaded onto your current image. I've never seen another program with this kind of design, but it works very well once you get the hang of it.

NOISE

Noise is the digital equivalent to film grain, and many digital images have some type of noise. When you apply the Flood filter, the reflection is devoid of noise. Therefore, it is important to reintroduce noise into the reflection so that it matches the rest of the photo. Depending on the ISO you used to take the picture, the amount will vary. In Photoshop, go to Filter>Noise>Add Noise. A dialog box opens into which you can enter the amount desired. I find that for a picture taken at ISO 200 with an 11-megapixel Canon, 4.8 is usually the correct amount. Your camera and the file size you are working with may require a different number, but it will be close to this. A setting between 4 and 6 is usually effective. You only need to apply the additional noise to the reflection using a layer mask, and not to the rest of the image.

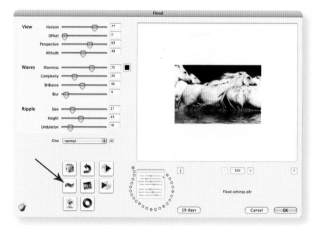

FIGURE 6
The Random Seed icon will change the wave pattern while retaining the positions of the other sliders.

CREATIVE POSSIBILITIES

All of the examples of Flood up to this point show a straight horizon line. In many instances, this looks very realistic, but in other images it doesn't work. You can define your own horizon line with excellent results, and this is often more suitable for a scene where a straight horizon looks artificial.

For example, in **PHOTO H** I used the Lasso tool in Photoshop to select an area in the middle-right of the landscape. I wanted to create a smaller body of water that followed the natural contour of the hills. Once the selection was made, I followed the same steps (only with slightly different settings to match the scene) for applying the filter as described earlier, and the filter was applied to just the selection area.

In **PHOTO I,** which shows the ruins of a 200-year old church in Beaufort, South Carolina, I used the Pen tool to carefully make a selection along the base of

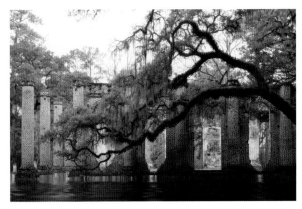

PHOTO I
Flood was applied twice to this image using selections. This repeat application made the water seem calm in some areas and rippled in others.

the brickwork and into the recessed area between the columns on the left. The Pen tool in Photoshop is the most precise way to create a selection. It is time consuming, but in the end it will give you the best results for creating detailed selections. (For a tutorial on how to use the Pen tool, see page 61.) Notice that the edge of the reflection is not a straight line. Instead, it follows the contour of the structure thanks to the selection I made.

For **PHOTO I,** Flood was actually applied two times to achieve the textured look of the water. First, I used the filter with no waves or ripples, and then I applied the filter again, adding ripples. The second time I used the lasso tool and selected the area in the reflection where the next application of Flood would occur. Once the selection was made, I feathered the edge 20 pixels so there would be a smooth transition between the first and second reflection. The result is a combination of effects: The water at the edge of the church is smooth while the foreground has more dimension.

35

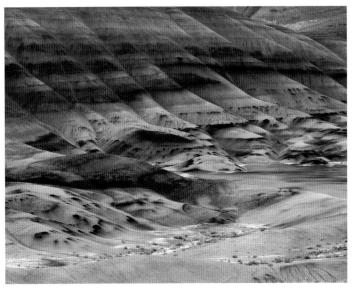

PHOTO H

PHOTOMATIX PRO 3.0
{ BY HDRsoft }

Photomatix Pro is a fantastic program that merges photos of the same scene taken at different exposures into one composite image with a tremendous dynamic range. Dynamic range is the term used to describe the amount of detail that can be seen in the shadows and the highlights in a single image. Both film and digital technology are limited in the detail they can capture in highlight and shadows, but with the aid of photo editing software, several exposures of a scene can be combined so we have the best of all worlds— detail in the very dark and very light portions of the image. Our brain interprets scenes in a way that displays dynamic range, so what we are basically doing is trying to reproduce a scene the way we normally see it. Photoshop has an HDR feature built into it (go to File>Automate>Merge to HDR to compare), but I use Photomatix Pro because it has more features and allows for the composited HDR image to be tweaked to a great extent.

NEED TO KNOW

Website: hdrsoft.com

Price Range: $ $ ◯ ◯ ◯

Notes: The trial version is fully functional and never expires, but it applies a watermark to images produced with some of the software's methods.

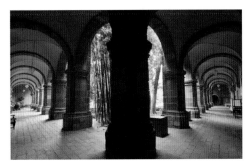

PHOTO A

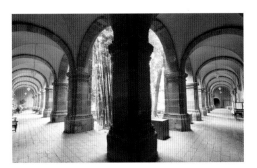

PHOTO B

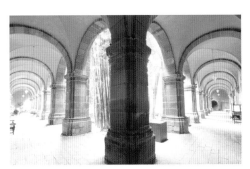

PHOTO C

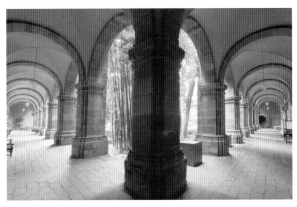

PHOTO D

A typical HDR sequence can be seen in **PHOTOS A, B,** and **C.** I used only three exposures for the composite, but you can see that in the originals it was impossible to hold detail in both the highlights and the shadows. When they were merged into a single picture, **PHOTO D,** I was able to show good detail throughout the image.

HDR THEORY & PRACTICE

In creating an HDR composite, you will start by photographing the same subject three or more times. One of the exposures will be "correct," and the others will be overexposed and underexposed. I suggest that you use one-f/stop increments between the exposures. When these images are placed into a folder together, the Photomatix Pro software can blend them together so the overexposed shadows can be combined with the underexposed highlights to comprise a single picture where you can see detail throughout.

Setting Up the Shot

Before we get into the software, there are several things you need to know regarding the photography and how you set up the camera for an HDR shot. There are two methods I'll discuss, but if you are as critical in your work as I am, you will be using the first method most or all of the time.

Method One: The images that comprise the final composite must be aligned perfectly. Photomatix can adjust for small variations, but it is best to use a tripod when you take the pictures to insure the final image will be tack sharp. I also use either a cable release or a 10-second self-timer and the mirror lock-up feature to make sure the pictures will be as sharp as possible. Normally, you wouldn't use a tripod for a photo taken in bright sunlight. However, if you want to reveal the detail in the shadow areas, HDR is the perfect solution—but only if you use a tripod for accurate alignment.

PHOTO E

PHOTO F

In the Mexican courtyard seen in this series of photos, the contrast was very high. I took eight different exposures, and the two extremes are shown here in **PHOTOS E** and **F.** Notice how underexposed I made the latter to hold onto the detail in the cobblestone. In **PHOTO E,** I grossly overexposed the image so the deep shadow areas could be seen clearly. The HDR composite is a remarkable blend of the various tones in the eight exposures. I added color saturation in the Tone Mapping dialog box to produce **PHOTO G.**

PHOTO G

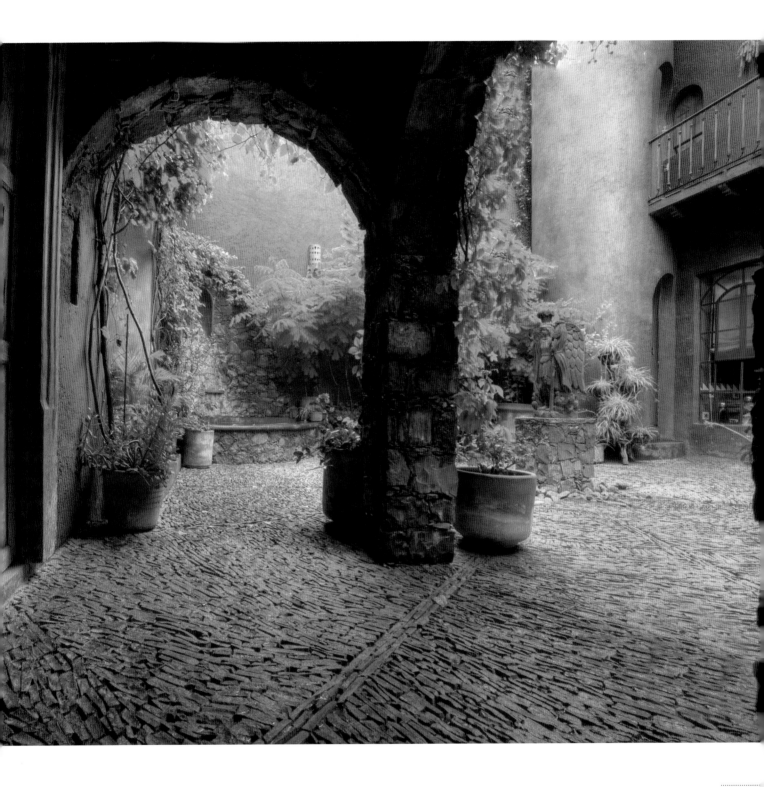

The camera must be switched to manual exposure, and you should be shooting in RAW as opposed to JPEG mode. JPEGs only provide 256 colors, while RAW has about 4,000 colors. This will give you a lot more detail and a smoother transition between the colors in the final image.

When you get ready to shoot, you must first choose the aperture setting. This is determined by how much depth of field you need. Merging photos together with different amounts of depth of field doesn't work, so each photo must be taken with the same f/stop. This is especially true the closer you get to a subject, like a close-up of a flower, where depth of field is critical. Merging a sharp background with a soft one just wouldn't work. Therefore, adjusting the shutter speed is the only way to vary the exposure.

Now choose the item from the camera's menu that allows you to see the histogram when you shoot, and select the "blinkies" option—the flashing highlight warning that appears when the bright areas of the composition are going to be overexposed with no detail. This function should be turned on because, when you take a meter reading of the scene, you want to use the shutter speed that will give you the brightest exposure without any blinking (or blown out) areas. If the first exposure shows flashing highlight warnings in the LCD monitor, simply change the shutter speed to reduce the exposure until you are satisfied that none of the highlights will be blown out and detail will be captured.

From this starting exposure, take several more frames where you increase the exposure in one-f/stop increments; this is opening up the shadows until all the shadow detail is revealed. Stop taking pictures when about half the image is blinking with the highlight warning. Remember that the lens aperture is staying the same and only the shutter speed is changing, and that each exposure should be made on a tripod.

Twilight and night photography can benefit from HDR because the contrast can be so extreme. I used three photos to create the composite, **PHOTOS H, I,** and **J.** The final composite, **PHOTO K,** shows more detail than I was ever able to capture before HDR was available. Notice how much detail was retained in the trees, the cathedral, and the sky.

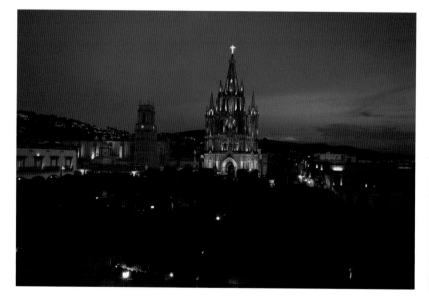

PHOTO H

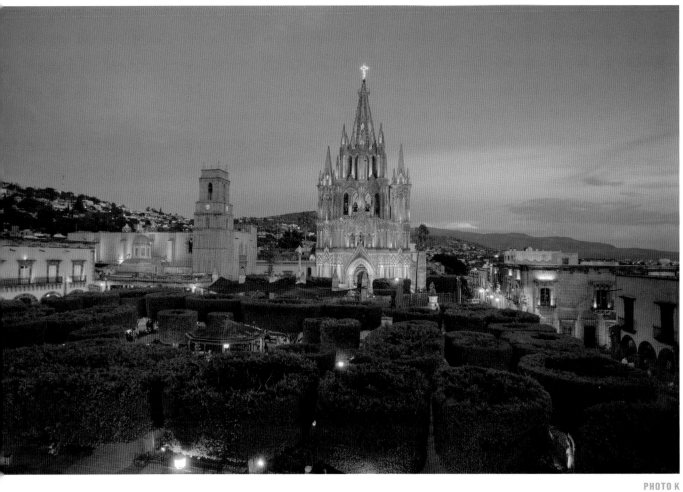

PHOTO K

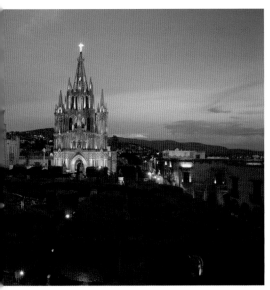

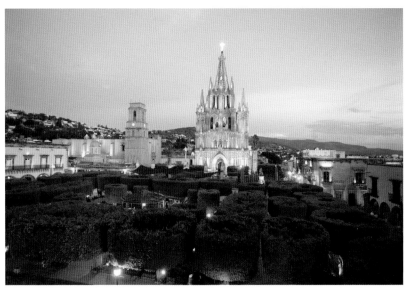

PHOTO I

PHOTO J

Method Two: If the absolute highest quality isn't a requirement, and you're willing to trade some quality for convenience, you can create the individual shots that I just described above from either a monopod or while handholding the camera. You can do this with Autoexposure bracketing, or AEB. AEB is a feature that many cameras use to fire off several frames sequentially. You can program the camera to change the exposure over those sequential images in any f/stop increment you want.

For example, if you want five exposures, make one of them based on what the meter reads, two of them lighter than this (separated, for example, by one-f/stop increments), and two of them darker than what the meter dictates. The camera will complete this command within a couple of seconds. You have to use Aperture priority because, as I said before, each of the images should have the same depth of field. Because you will be handholding the camera, you'll want shutter speeds that are fairly fast. If the lighting is low, you

will probably have to increase the ISO to a level that will enable the camera to use shutter speeds that will give you sharp pictures.

Obviously, the images will not be perfectly aligned with each other. When Photomatix puts the frames together into a single composite, it does a pretty good job of merging them, but it's not meticulously accurate. If you are going for a tack sharp photographic image, then you need to use a tripod.

When you have taken the photo sequence that will be combined into the final HDR image, open them in your RAW converter, but don't manipulate them. Just save them as 16-bit TIF or PSD files on your desktop. The 16-bit file will be double in size compared to an 8-bit file, but it will have a lot more information that Photomatix will use to your advantage. Create a folder on the desktop into which you'll drag all the images. The order of the photos or their numbering sequence doesn't matter—Photomatix will merge them all.

FIGURE 1
Use the Workflow Shortcuts palette to create an HDR image. Clicking the Generate HDR Image button is the first step.

USING PHOTOMATIX PRO

When you open Photomatix Pro, a small dialog box labeled Workflow Shortcuts opens **(FIGURE 1).** The first two buttons, Generate HDR Image and Tone Mapping, outline the two-step process involved in creating high dynamic range photographs. The first step is to merge the photographs into a single 32-bit HDR image. Due to its high dynamic range, an HDR image will not display properly on conventional monitors. In order to see the correct result, you must process the image using the

FIGURE 2

FIGURE 3

second step, Tone Mapping. Think of this step as similar to developing your image in the darkroom. Tone Mapping will reveal the dynamic range captured in the HDR image and produce a picture that can be properly displayed on conventional monitors. This image can then be printed on the paper of your choice.

Generating the Image

Start the process by clicking the Generate HDR Image button in the dialog box; in the next dialog box that shows up (FIGURE 2) browse your computer to find the folder containing the bracketed photographs that will comprise the HDR composite. When the photographs appear in the window, click OK.

A third dialog box, Generate HDR-Options (FIGURE 3), now appears. I would recommend checking off the boxes that you see here—you will want Photomatix to align the source images. If you opt for 'By matching features' alignment, the program will correct for any misalignment that occurred not only

due to horizontal or vertical movements, but by a rotation mismatch as well. This is especially useful if you handheld the shots, but even if they were shot using a tripod, movement can still sometimes occur.

If the scene has moving objects, and you want to get rid of the ghosting, then check 'Attempt to reduce ghosting artifacts'. If your scene has moving people, cars, blowing leaves, etc., use 'Moving objects/people'. For flowing water or the like, check the 'Background movement' option.

In the last three choices, check 'Take tone curve of color profile' if your images were taken with a digital camera. If you scanned slides or negatives for this process, then opt for 'Attempt to reverse-engineer tone curve applied'. Now you can click OK and the HDR image will be processed.

Remember that conventional monitors can't show you the detail that you will soon see. The resulting image will look contrasty and disappointing, but that's because you have only completed the first step.

Tone Mapping

The generated HDR image cannot be represented correctly on your screen without further processing, or Tone Mapping. You can access the Tone Mapping dialog box by clicking on the Tone Mapping button in the Workflow Shortcuts palette or by using the pull down menu Process>Tone Mapping. Once the dialog box is opened, there are two tone mapping methods for processing the HDR image, Details Enhancer and Tone Compressor; buttons for both appear at the top left of the dialog box (SEE FIGURE 4). You can use one or both of them; they give you different end results separately, but they can also work together. The Details Enhancer takes into account the photos' context. In other words, if they are in a light area or a dark area, Photomatix alters them to blend in with the surrounding tones. The Tone Compressor method adjusts the image without taking into account the local context. This makes the result free from noise and halo artifacts, but lacking local details and contrast.

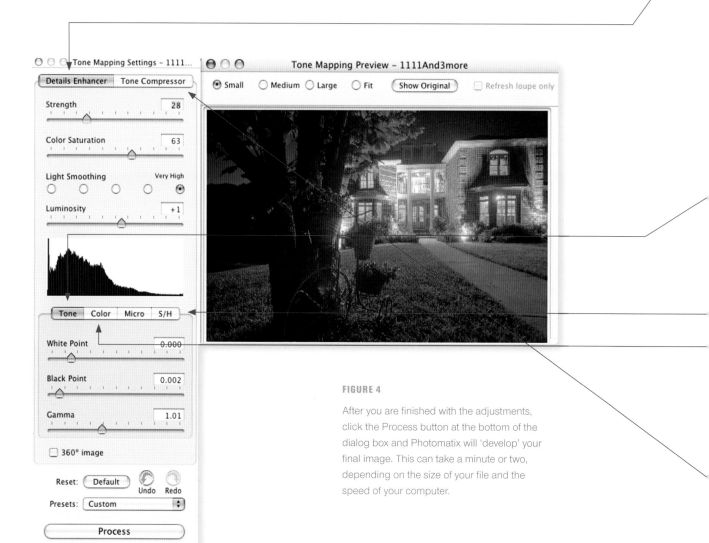

FIGURE 4

After you are finished with the adjustments, click the Process button at the bottom of the dialog box and Photomatix will 'develop' your final image. This can take a minute or two, depending on the size of your file and the speed of your computer.

1.

Details Enhancer: The name of the sliders in the top half of this dialog box are fairly self-explanatory: Strength, Color Saturation, Light Smoothing, and Luminosity. The best way to familiarize yourself with these options is to experiment on an image and visually assess whether or not you like the results. Suggesting settings here won't work well because the effects are entirely dependant on the image being used.

As you make changes, they will appear in the preview window on the right. The size of the window can be changed using the buttons above the preview image. This preview is not always an accurate representation of the final tone mapped image, but it's quite close. If you want to get a closer look at part of the image, click on it with your cursor, which looks like a square. This will magnify the portion of the image inside the square.

2.

Under the **Tone** tab, you will see the White Point and Black Point adjustments sliders. These control contrast with respect to the maximum and minimum tonal values for the blacks and whites. I find that they usually need to be moved to the right a little because otherwise the image will look too flat. The Gamma slider controls the mid-tones and brightens or darkens the entire image.

3.

When you click on the **Color** tab, you'll see three sliders that affect the white balance and the saturation of the image. Under the Micro tab, you can minimize the digital noise in your picture by using the Micro-smoothing slider. This is especially useful in shadow detail and in large, dark areas like a night sky. The Microcontrast slider can be used to accentuate details in the image. A contrast increase will always bring out the graphic shapes of the various objects in your pictures.

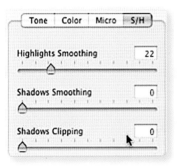

FIGURE 5

4.

Under the **S/H (shadow/highlight)** tab, you will see another set of options **(FIGURE 5)**. Here you can reduce the contrast separately in the shadows and highlights. The Highlights Smoothing slider is used to prevent the highlights from turning gray. It can also be used to reduce the halo around subjects when they are photographed against bright backgrounds. The Shadows Clipping slider is useful to cut out digital noise in dark areas of a scene that was taken in low light, such as a living room or a pub. The Shadows Smoothing slider reduces the contrast enhancements in the shadows. The value of the slider sets how much of the shadows range is affected.

If you want to save the tone mapping so you can apply the same choices to future images, go to Process>Save Settings in the Photomatix pull-down menu.

5.

Tone Compressor: When you click on the Tone Compressor tab, you are presented with more sliders that tweak the color, white balance, and contrast of the image in various ways. Experiment with each of them and see what they do. If you get to a point where you feel you've made a mess of things, you can undo all of the tone mapping adjustments by using the pull-down menu Edit>Undo Tone Mapping.

Exposure Blending

Photomatix offers an alternative to tone mapping an HDR image called Exposure Blending, and it offers two main advantages. First, it reduces noise in your image whereas HDR and Tone Mapping amplify it. Second, Exposure Blending is simple and easy to use with only a few parameter settings, which you don't even have to use. **PHOTO L** is an example of where I used Exposure Blending. The main advantages of this method of expanding the dynamic range are that it avoids the painterly look,

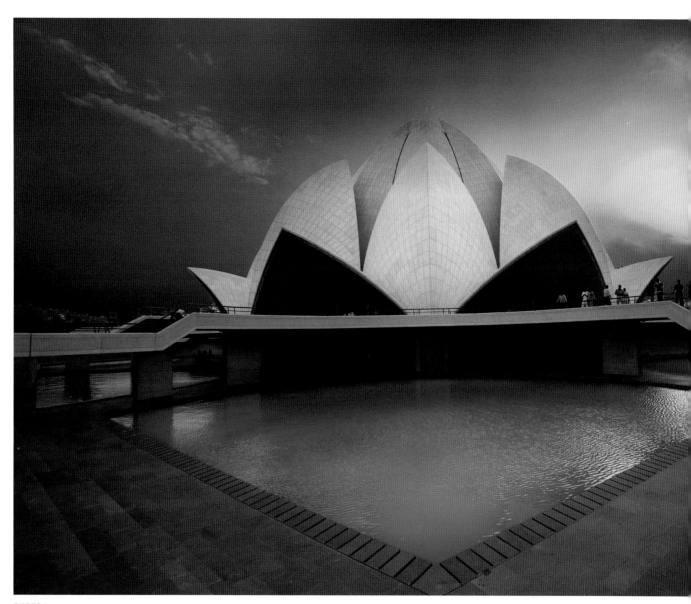

it shows fewer artifacts like halos and gray clouds, and it reduces noise. The button for Exposure Blending can be found on the Workflow Short-cuts palette that first appears when Photomatix is opened.

One detriment to Exposure Blending is that the memory required for blending exposures increases with the number of source images, which can really slow your computer down. 16- or 32-bit depth photos will require more memory, too.

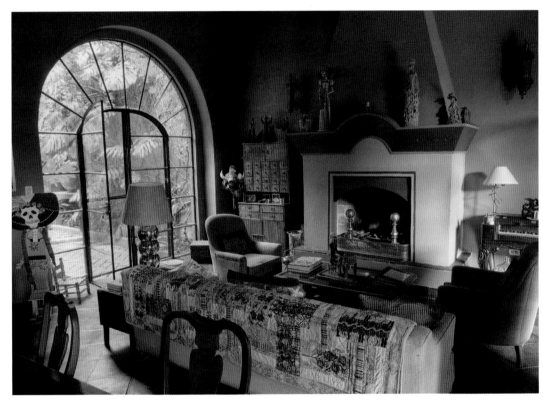

PHOTO M

One of the challenging exposure situations that has always plagued photographers is shooting indoors where there are bright windows that are many f/stops lighter than the dark recesses of the room. Inevitably, the bright exterior is totally blown out. Only if artificial lighting is used to make the room as bright as the outdoors can a photographer expose both areas correctly. Now with Photomatix, it's easy to expose for all areas in a composition. **PHOTO M** is a great example. Even though the exterior courtyard was illuminated by an overcast sky, the living room was so much darker that it would have been an impossible lighting situation in the past. With HDR, I was able to get a good exposure throughout the image.

CHAPTER 2

TWO

Liquify, p50

Color Efex Pro 3.0, p62

Silver Efex Pro, p78

WALK ON THE WILD SIDE

Darkroom techniques of the past only took photographers so far when altering slides, negatives, and prints. There were technical and creative limits beyond which even the best darkroom masters just couldn't go. In the digital realm, however, there are no limits at all—the barriers constraining creativity have all come crashing down. Photoshop and the plug-ins that work within it are only limited by our imagination. We can now turn our photos into fine art, we can get wild and delve into surrealism or fantasy, and we can embellish our images with resonant subtlety. Whatever you can imagine you can do—and more. With the plug-ins in this chapter, you may find techniques you've never even thought of before.

Liquify comes standard in the Photoshop Filters menu; with it, you can do anything from subtly changing a person's facial features and body shape to creating warped images of people, buildings, animals, landscapes, and just about anything else. Liquify isn't thinking outside the box...it's thinking outside the known Universe.

Nik Color Efex Pro is a suite of filters that will enhance and embellish your photographs in countless ways. With non-destructive editing, simplified layer masking, and high-end photography specific effects, it's a plug-in used by countless pros who need to get the job done right. To get stunning interpretations of your images in black and white, turn to Nik Silver Efex Pro. You can simulate the rich tones seen in the classic works of black-and-white masters like Ansel Adams, and then go beyond that by combining the black-and-white image with the color original for a new wave of photographic experimentation.

49

LIQUIFY

The Liquify filter is not something you have to buy because it is now native to Photoshop. Corel Painter first developed this method of manipulating images and they called it Distorto. I include it in this book because it is a unique and creative tool, and I want to explore some of its remarkable possibilities with you. This filter distorts the shape of any part of a photo so you can stretch, elongate, twirl, pull, or exaggerate the lines and shapes in the image. You can turn a photo into a complete abstraction or use Liquify judiciously to slightly enhance or modify the original. It can be applied to images that are either 8-bits or 16-bits per channel.

THE DISTORTION TOOLS

The Liquify filter can be found under Filter>Liquify in the Photoshop menu bar. A large dialog box opens that takes up your entire desktop, and on the far left side there are several tools that distort your image in a variety of ways. If you hold the cursor over each icon, its name will appear. On the next page is a list of the tools and what they do, starting from the top of the tool bar and going down. Click on each tool and experiment with it to see what it does. Notice that as you drag the cursor over an area of the photo, the filter effect intensifies.

NEED TO KNOW

Website: adobe.com

Price range: Free

Note: There is no need to download any software for this filter; it is included in Photoshop.

Note: Before you open the Liquify dialog box, be aware that this is a slow filter. If you are working with a fast computer, it's not so bad, but if you are using an older model you may get frustrated with Liquify because it takes its sweet time to render the image once you've applied the distortion. If you are working on hi-res files, just opening the dialog box can take a frustratingly long time. However, if you know you want to work on a small area of the composition, say the nose of a person, you can select just that portion of the image with the Rectangular Marquee tool. Liquify will be able to work much faster because you will only see the area you selected in the image preview part of the dialog box.

Following is a list of the distortion tools and an example of the effect they have on an image. Compare each tool's distortion to the original image **(FIGURE 1)** to understand how it changes a picture.

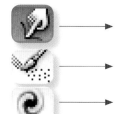 **Forward Warp tool:** This tool pushes the pixels forward as you drag the cursor. This is my favorite tool in Liquify **(FIGURE 2)**.

 Reconstruct tool: This tool brings back the original image when used over a liquefied area.

 Twirl Clockwise tool: This tool rotates the pixels clockwise as you hold down the mouse button and drag. To twirl pixels counterclockwise, hold down Alt (Windows) or Option (Mac) as you hold down the mouse button and drag **(FIGURE 3)**.

 Pucker tool: This tool moves the pixels toward the center of the brush area as you hold down the mouse button and drag the cursor **(FIGURE 4)**.

Bloat tool: This tool moves the pixels away from the center of the brush when you hold down the mouse button and drag the cursor **(FIGURE 5)**.

Push Left tool: This tool moves the pixels to the left when you drag the tool straight up (pixels move to the right if you drag down). You can also drag clockwise around an object to increase its size, or drag counterclockwise to decrease its size. To push pixels right when you drag straight up (or to move pixels left when you drag down), hold down Alt (Windows) or Option (Mac) as you drag the cursor.

Mirror tool: This is a very creative tool that copies pixels to the brush area. You drag the cursor to mirror the area perpendicular to the direction of the stroke (to the left of the stroke). Alt-drag (Windows) or Option-drag (Mac) mirrors the area in the direction opposite to that of the stroke (for example, the area above a downward stroke). Usually, Alt-dragging or Option-dragging gives better results when you have frozen the area you want to reflect (see below for the tool that does this). You can use overlapping strokes to create an effect similar to a reflection in water **(FIGURE 6)**.

 Turbulence tool: In use, I don't see much difference between this tool and the Forward warp tool **(FIGURE 7)**.

Freeze Mask tool: You can paint over an area of the image to protect it from being affected by the distortion brushes. This in essence acts as a mask or a selection.

Thaw Mask tool: This unfreezes the sections of the photo that you froze. This is very similar to painting away a layer mask with the paintbrush tool in Photoshop. If you want to reverse the frozen areas and the thawed areas, you can click Invert All in the Mask Options area on the right side of the dialog box **(FIGURE 8)**.

FIGURE 1 Original

FIGURE 2 Forward Warp tool

FIGURE 3 Twirl Clockwise tool

FIGURE 4 Pucker tool

Tool Options

There are a number of options on the right side of the dialog box that control how the distortion is laid down. Brush Size changes the width of the brush; you can use either the numerical slider or, as with other tools in Photoshop, you can change the size of the brush two points at a time with the bracket keys on the keyboard. The left bracket makes the brush smaller and the right bracket makes it larger. Brush Pressure modifies the speed of the distortion. A low pressure makes the distortion occur slowly, while a high pressure makes the distortion quickly rip through your image.

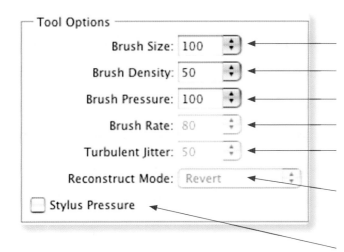

Brush Size controls the width of the brush.

Brush density controls the intensity of the brush's effect.

Brush Pressure modifies the speed of distortion.

The Brush Rate controls how fast that rotation occurs.

Turbulent Jitter controls how tightly the Turbulence Tool scrambles pixels.

The Reconstruct Mode is used for the Reconstruct Tool. It offers eight style options for how the Reconstruct Tool reverts back to the original in the preview image.

The Select Stylus Pressure box is used only when working with a stylus and tablet like those Wacom produces. When selected, the brush pressure for the tools is the Stylus Pressure multiplied by the Brush Pressure value.

FIGURE 5 Bloat tool

FIGURE 6 Mirror tool

FIGURE 7 Turbulence tool

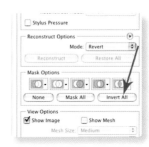

FIGURE 8

MASK OPTIONS

When you work with an image that has a mask or selection, you can apply the Liquify filter to that specific area. When you create a selection or mask, this gives you precise control over which portion of the image is affected by Liquify. You can modify the selection or mask in the Liquify dialog box without the need for returning to Photoshop to do the work.

If you want to save the distortion design you created in an image so you can recall it later, simply click Save Mesh. This is just like using Select>Save Selection, where Photoshop saves a selection and makes it an alpha channel. When you want to recall the distortion pattern later, use the Load Mesh button.

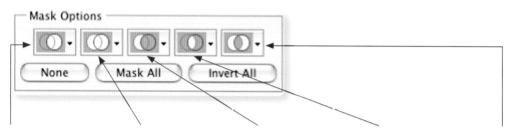

Replace Selection: This option shows the selection, mask, or transparency in the original image. You can replace the selection with a mask to protect it from being altered by Liquify.

Add to Selection: This option shows the mask or selection in the original image, which can then be added to using the Freeze Tool. This tool adds to the existing mask or selection so you can increase the size of the frozen area not affected by the Liquify tools.

Subtract from Selection: This option does the opposite of Add to Selection; simply, it allows you to remove area from a selection or mask using the Thaw Mask tool.

Intersect with Selection: This tool allows you to apply the Liquify brushes only to pixels that are selected and currently frozen.

Invert Selection: This function is just like inverting a selection in Photoshop. The areas that are masked become un-masked, and the areas that weren't masked are now protected by a mask.

Reconstruct: The button in the middle of the controls named Reconstruct is like a multiple undo. Hit it several times and you will see the distortion commands delete in the reverse order they were laid down. If you want to reset the image with all commands in this dialog box eliminated, just hit the Restore All button.

WORKING ON PEOPLE

Liquify is more than just an abstracting filter. It can also be used quite successfully as a way to alter people's physical appearance.

PHOTO B
Use the Liquify tool to subtly change parts of your subjects' appearance. In **PHOTO B**, the dancer's waist was slimmed slightly.

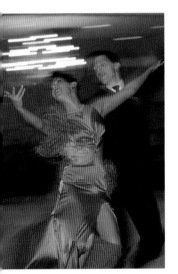

PHOTO A

Bodies

We'll use **PHOTO A** as our first example of ways to think about using Liquify. Ballroom dancers are very hard to shoot because their movements are extremely animated, but my on-camera flash gave me a sharp image. At the same time, my 1/20 second exposure allowed the ambient light to record an image that was blurred, and the blurred abstraction was superimposed over the sharp image from the flash. That's what you see here. It looks almost like a double exposure, but it was done in one shot.

FIGURE 9

The female dancer in this photo was in great physical shape, but I thought it might be an interesting experiment to apply Liquify to narrow her body. I started by first clicking on the Rectangular Marquee tool to select only the portion of the image on which I would be working. **FIGURE 9** shows just the dancer's body in the Liquify dialog box.

To make the waist of the dancer narrower, I used a fairly small brush and slowly pushed the two sides of her body inward at several points using the Forward Warp tool. Be careful not to go too far or the result will no longer appear realistic. To make the new waist curves look natural, I worked in very small increments using a small brush size until I liked the result and then clicked OK. **PHOTO B** is the resulting image; the difference is subtle yet significant.

I did the same thing with **PHOTO C,** a picture taken during Carnival in Venice. Notice in the filtered image, **PHOTO D,** that I not only narrowed the woman's waist, but I also reduced the size of her arm. In using Liquify to expand the space between her arm and her waist, the stonework was stretched and distorted. The original area of wall there was so small that I didn't have much to work with. Therefore, I used the Clone tool to replace that area with stone texture from the background to the left of the model.

PHOTO C

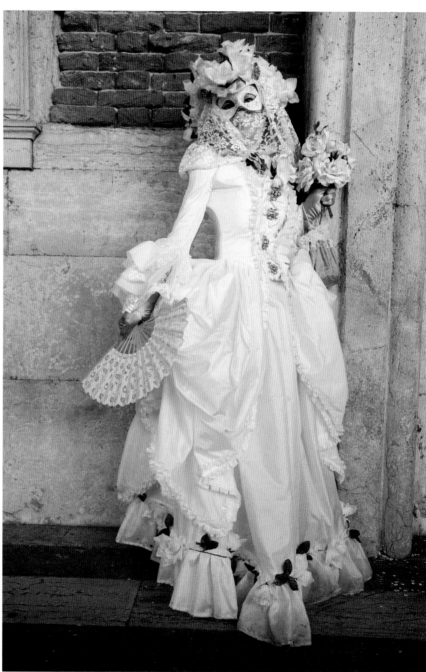

PHOTO D
For this photo, I slimmed the subject's arm and waist using Liquify, and then used the Clone Stamp tool to fill in the stonework background in the space created.

Facial Features

Using Liquify to alter a subject's face, you can virtually change the identity of someone or you can merely alter their features just enough to enhance (or detract from) their appearance.

Look at the simple portrait in **PHOTO E** and then compare it with the altered version in **PHOTO F.** I enlarged the eyes, narrowed the nose, and extended the mouth slightly. I used the Forward Warp tool to make all of these changes, and the difference is small but noticeable. I used a brush size approximately the diameter of one of the model's eyes, and I made the changes in very small increments. The only way you can judge if you are using small enough increments is to see whether or not the pixels look unnaturally stretched, which should be very obvious. You have to be careful because a gross change can distort the person's face in a way that you may not want.

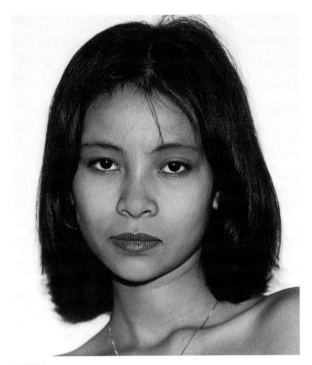

PHOTO E

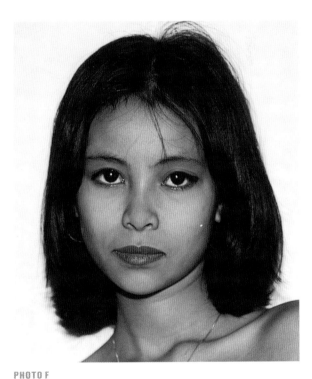

PHOTO F

Even small changes to a subject's face can make a big difference. I used the Liquify tool on **PHOTO E** to make the subject's eyes larger, slim the nose, and extend the mouth just a bit. The results of the work can be seen in **PHOTO F.**

PHOTOS G and **H** show where I used the same technique on a young Indian dancer's face. I narrowed her nose to make it thinner. This took me about three or four minutes and I used the same brush (the Forward Warp tool) for the entire operation. I narrowed the nose along the outer edges by pushing it inward, and I also worked on the nostrils to make them slightly smaller. Even the subtlest changes in a face can make a significant difference in a person's appearance—after all, this is exactly what plastic surgeons do.

PHOTO G

WILD ABSTRACTIONS

Liquify can be used to create amazing abstractions on virtually any subject. Brilliant, colorful subjects work great, and I also like to work with images that have strong graphic design elements, such as **PHOTO I.** I shot this stunning tulip in Holland, and in **PHOTO J** I applied the Turbulence tool and then the Pucker tool to produce an image that is really nothing but color and abstract design.

PHOTO H

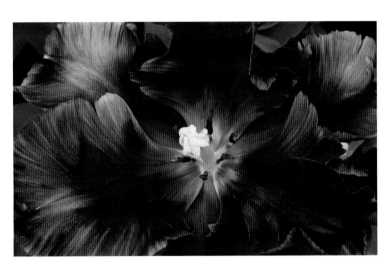

PHOTO I

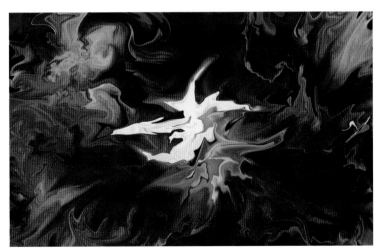

PHOTO J

59

Allow yourself to get carried away by the fun experimentation this filter offers. In **PHOTOS K** and **L,** I used the Forward Warp tool to pull areas of the Carnival participant outward, creating a wild graphic interpretation. I also used Filter>Adjustments >Hue/ Saturation to enhance the colors quite a bit, adding to the surreal effect.

In another surreal example, **PHOTO M,** I took a sunset picture and applied the Pucker tool to abstract the clouds and blend them into the silhouetted mountain chain at the bottom of the frame. I then used the Pen tool (see sidebar, opposite page) in Photoshop to cut out a dead tree, a stork, and a pair of giraffes from other pictures. Once I had these three components selected, I filled them with black using Edit>Fill, copied them, and then pasted them into the abstracted sunset image for a very different kind of African landscape.

PHOTO K

PHOTO L

PHOTO M
Liquify can be used to create dream-like abstractions.

USING THE PEN TOOL

The Pen tool is not understood by a lot of Photoshop users, especially photographers, so I wanted to give step-by-step instructions for how I composited the animals and the tree with the sunset image in **PHOTO M.** At this time, Photoshop Elements does not have the Pen tool, so if you are using this program you can substitute it with the Lasso tool. The Lasso tool works differently, but the results will be the same. I prefer the Pen tool because it is a precise way to cut out and separate a subject and it's easy on your hand.

For Elements users, when you use the Lasso tool and you are outlining the subject, you will come to the edge of the image area frequently since the picture will be enlarged quite a bit. Press the space bar without releasing the Lasso tool from the photo. The Lasso tool turns into the Hand tool and now you can move the image to give you more working area. Release the space bar and continue working.

Photoshop Users:

1. Enlarge the image 200-300%.

2. Click on the Pen tool.

3. Click on the edge of the subject that you want to cut out and place dots (formally known as anchor points) from the pen tool as you follow along its shape. The more dots you use, the finer and more accurate your selection will be.

4. If you make a mistake, you can click and hold on the Pen tool icon in the Tools palette and you will see several sub-tools. Choose the Delete Anchor Point tool and then click on the dots in your picture that you want to remove. When you are ready to continue, click again on the original Pen tool and touch the last dot in the chain—the one that you wish to start from—and then continue.

5. When the last dot connects with the first dot, you have completed the circuit and created a path.

6. In the Paths palette (Windows>Paths), there is a tiny arrow in the upper right corner. Click this and a sub-menu is revealed. Choose Make Selection; in the dialog box that opens, type in 1 pixel.

7. Now you have a selection. To make the image a silhouette, simply use Edit>Fill and choose the Foreground Color (making sure the foreground color box is black) and then click OK. You can now copy and paste your selection into other images.

COLOR EFEX PRO 3.0
{ BY NIK SOFTWARE, INC. }

Nik Software, Inc. makes a collection of great filters that are bundled together in a plug-in called Color Efex Pro 3. This plug-in offers a tremendously diverse range of creative effects and image-correction tools that many photographers, designers, and computer artists have come to rely on. From enhancing images with subtle artistic improvements or transforming them with wild and surreal effects, Color Efex Pro is a grab bag of useful filters. It is also a big boost to efficiency because it combines several digital photography effects into a single plug-in.

By working in one window, you can be adding grain, introducing diffusion, adjusting the contrast, and vignetting the edges of the frame without having to navigate through numerous menus and tools. And since each filter in Color Efex Pro can be tweaked considerably, working with this plug-in can produce photographic styles with almost endless variations.

WORKING WITH COLOR EFEX PRO

To begin, open an image in Photoshop and open Color Efex Pro from the Filters menu. Once the main Color Efex Pro dialog box is open, you will see all of the filters listed in a column on the left (SEE FIGURE 1); there are also five tabs along the left edge of the box (A) that read: All, Traditional, Stylizing, Landscape, and Portrait. Choosing among these tabs allows you to view filters categorized by these subgroups, but personally I find it easier just to view them all at once. By clicking on the All tab (which is the default setting), you will be able to access the entire list of filters at a glance.

FIGURE 1

A

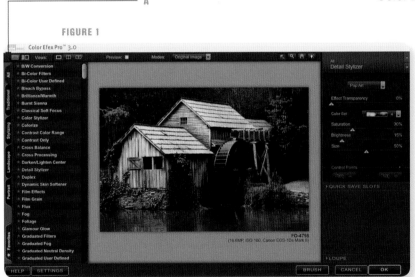

When you select each filter, a set of slider bar controls appear in the upper-right section of the dialog box. The generous preview window makes it easy to see how the image is being altered as you change the settings with these sliders. Once you hit OK, Nik filters are automatically applied as a separate layer, which means they can be combined with the original image in all the ways that Photoshop allows for, such as blend modes, layer masks, opacity, and so on.

Using Nik Layer Masks

Layer masks can be created and altered within the Nik software by clicking the Brush button at the bottom of the dialog box, indicated by the arrow in **FIGURE 2.** (For more information about layer masks, see page 10.) Clicking this button closes the current dialog box and opens one specific to the brush **(SEE FIGURE 3).** At the same time, a new layer will appear in the Layers palette in Photoshop. Here's where layer masks get a little tricky: Look at the new layer's preview closely in the Layers palette. You'll see that the new layer has the filter you chose from the Nik software already applied to it. Also note the black icon to the right of the preview image—this is the actual layer mask. When you click the Paint button in the Nik dialog box and begin to paint on the image, you are painting away the overlying mask to reveal the filtered layer underneath. After painting, look at the layer mask icon in the Layers palette again. See how the mask now shows the brushstrokes you painted? It's almost as if you are cutting holes into the layer mask with the paintbrush to see the filtered layer below.

FIGURE 2

FO-4798
(16.6MP, ISO 100, Canon EOS-1Ds Mark II)

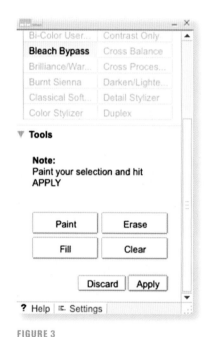

FIGURE 3
Use the layer mask palette in Color Efex Pro to simplify the masking process.

You must be using either the Photoshop Brush tool or the Gradient tool to use the Nik Brush option. The Brush allows you to paint away the overlying image (and you can vary the opacity of the brush) while the Gradient tool blends the new filtered layer with the underlying image. The Erase button will erase what you have painted,

just like when you toggle back and forth with black and white in the foreground/background boxes in the tool palette when working with a layer mask. When you click Fill, the filtered version of your photo will be seen in its entirety, and when you choose Clear you undo the filter so only the original image is seen. By clicking Apply, you apply the changes you've made.

PHOTO A was created using Nik's layer mask approach. I clicked on the Brush button and painted the surreal effect of the Detail Stylizer Pop Art filter over the original image of the mill.

While there are many great filters in this plugin, the following is a quick look at some of the best offered in the Color Efex Pro collection.

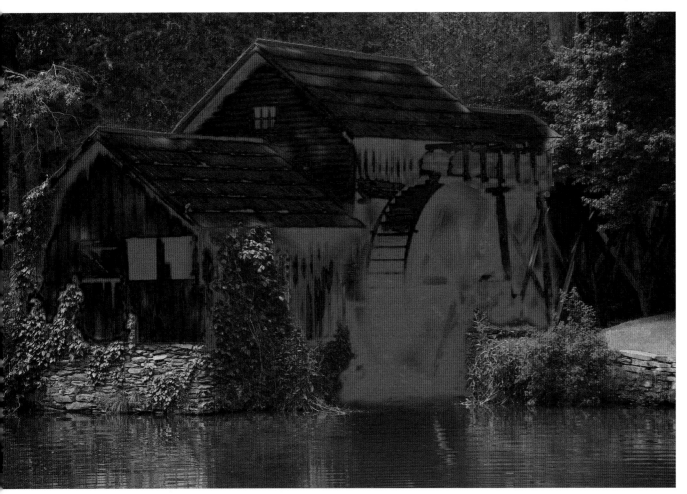

PHOTO A
By using a layer mask, I was able to paint the Pop Art filter onto the mill while leaving the background layer untouched.

DETAIL STYLIZER

One of the more unique filters in the Nik collection, Detail Stylizer produces psychedelic imagery by turning your pictures into a surreal soup of outrageous color. It abstracts the lines and forms in the original image so that it looks like a part-solarized and part-posterized darkroom effect. It never fails to be intriguing. If you are into surrealism, this is the plug-in filter for you.

FIGURE 4 shows the four slider bars that control this filter and the pull-down submenu called Color Set. Color Set reveals seven options that change the colors in the image as well as alter the light and dark relationship. Each choice is dramatic in its own right, and they are all very different from each other.

The Effect Transparency slider allows various parts of the original image to show through the wild colors produced by the filter. For example, **PHOTO B** shows an original picture I took of a horse running in ocean surf. By using the Effect Transparency slider after I had applied the Detail Stylizer filter, I was able to show definition in parts of the horse. In **PHOTO C,** the mane and the bridge of the horse's nose came through from the original thanks to Effect Transparency.

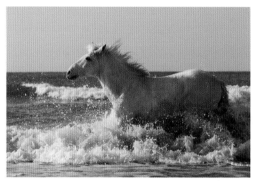

PHOTO B

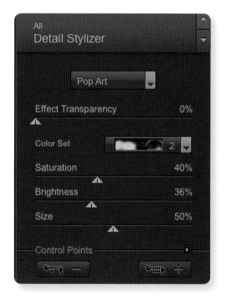

FIGURE 4

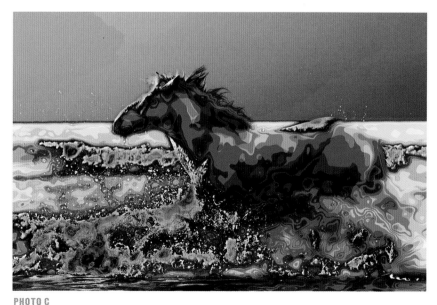

PHOTO C

Use Detail Stylizer to create surrealistic images like this horse. Try blending the original layer with the filtered layer to get a combination of realistic detail and surrealistic effect.

The Saturation and Brightness sliders are fairly self-explanatory; they affect the depth of color and exposure. The Size slider is very interesting, though; as you move it to the right, the areas of the image become less defined and become more like abstract globs of color. With **PHOTO D,** I wanted to abstract the original picture of Lake Geneva, Switzerland. So I set the Size slider to 74%, and the result can be seen in **PHOTO E**. Each picture you work on with the Detail Stylizer will surprise you because it will be a little different, and that's part of the fun.

PHOTO D

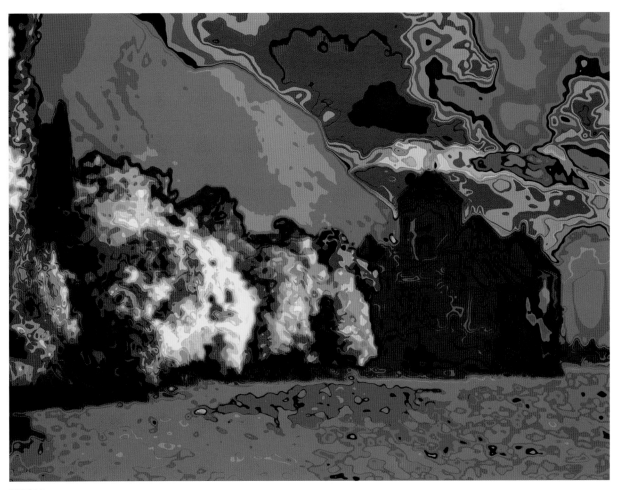

PHOTO E

MONDAY MORNING

There is a group of filters within Color Efex Pro called the Monday Morning filters. They are found under the Monday Morning filter in the main menu, and submenu options include Monday Morning Blue, Monday Morning Sepia, Monday Morning Green, and Monday Morning Violet. These filters add a moody artistry to photographs. They create a type of diffusion and muted color that, to me, look very similar in style to a lot of fine art.

PHOTO G

My two favorite color schemes are Monday Morning Blue and Sepia. In **PHOTOS F** and **G,** the original portrait of the Carnival participant in Venice was altered using the Monday Morning Blue filter. Another shot where I felt the same filter worked very well is the Leaning Tower of Pisa seen in **PHOTOS H** and **I.**

PHOTO H

While both of the original photos seen on these pages had dramatic tones, applying the Monday Morning Blue filter increased the intense, moody feeling substantially.

PHOTO I

SOLARIZATION

The original solarization technique was done in the darkroom by exposing photographic paper or film to light for a brief instant during the chemical development. There was very little control and it was a challenging technique to get right. The traditional solarizations were characterized by a reversal of positive and negative areas of the image, brilliant, surreal colors, and thin black 'machie lines' around the contours of the subject. Man Ray used this technique in black-and-white photos in the 1930s, and decades later photographers began experimenting with color solarizations. It was very popular in the 1960s, and this technique was used for art posters of the Beatles, Marilyn Monroe, and other pop culture figures.

In this digital age, solarization is much easier to achieve. Nik has incorporated several solarization filters into Color Efex Pro, both for black and white and for color.

Solarization can be found in the main filter menu, and when selected, two slider bars appear **(SEE FIGURE 5).** The Saturation slider controls how wild you want to get with the color (moving the slider all the way to the left turns it into black and white), and the Elapsed Time slider simulates the second exposure in the darkroom where the film or paper was exposed to light. This slider changes the relationship between how much of the image is positive and how much is negative. Unlike the original darkroom process, you can easily see the results in the preview window and choose the type of abstraction you like. In addition, the pull-

FIGURE 5
Use the slider controls in the Solarization dialog box to modify the intensity of the solarization.

down menu labeled Method offers six different color themes and six different black and white themes. This gives you an almost infinite number of possibilities for creating unique solarizations.

Using the Control Points menu, you can specify places in your photo where the solarization will not affect the image. It's like creating a mask so the filter only affects the areas that you designate. You must click the negative (-) Control Points icon every time you want to establish a new control point mask. **PHOTOS J** and **K** show a before and after sequence where I retained some of the yellow color in the original when the Solarize effect was applied. If you choose the positive (+) button, it will apply solarizations only to the points where you choose to place them. You can have several Control Points, and if you want to delete them, simply click on the gray circle representing the Control Point on the preview image and press Delete.

PHOTO J

PHOTO K
By using Control Points, I was able to retain some of the original image's yellow color after the filter was applied.

PHOTO L
For this image, I combined the original layer with the filtered layer using the opacity slider. This process displays the solarization technique while preserving lots of color from the original.

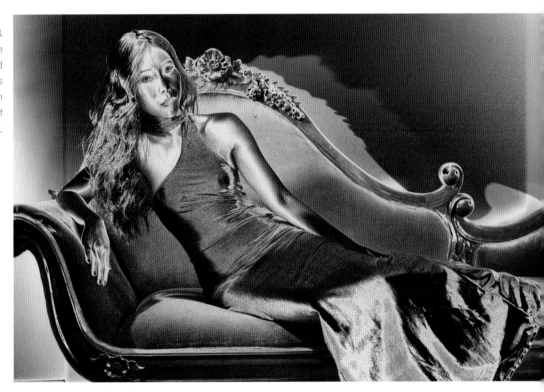

PHOTO L shows another variation where I didn't use any control points, but instead combined the solarized image with the original using the opacity slider. Remember that every time you apply a Nik filter, it becomes a layer. You can then combine it with the underlying original image using opacity, the blend modes, or a layer mask.

Solarization can be striking in black and white, too. The original **(PHOTO M)** was taken in color. **PHOTO N** is an example of a black-and-white solarization. Notice how the underside of the roof and the top of the truck cab are positive (meaning that the light and dark tones are correct), yet the grass, the cabin, and the lower part of the vehicle are mostly negative.

PHOTO M

PHOTO N

SUNSHINE

Like many of the filters in the Nik line-up, Sunshine does several things to an image at one time. Using the sliders available when this filter is selected, you can add a golden color, introduce a soft diffusion, add contrast, and increase grain. The name of the filter implies that it simulates the sun, but the truth is that in the digital realm you can't change the direction of the light. Sadly, the way the shadows fall on a scene or a subject can't be changed. The only way a filter can suggest sunshine is to add color and contrast, and that's what this filter does.

The slider bars that are available with this filter can be seen in **FIGURE 6.** As with many plug-in filters, as you experiment with the various creative controls you have to be careful about introducing too much contrast. Many sliders tend to add contrast to the image, and that's fine as long as the highlights don't get blown out—meaning they lose texture and detail so a bright area of the image becomes solid white. Using the Light Intensity slider, for example, has to be used carefully for this reason.

The filter can be applied to a wide variety of subject matter. It's great with portraits, as you can see in **PHOTOS O** and **P.** Notice how the filter made the latter photo come to life; the young girl's skin looks healthier and the overall image is much more attractive.

PHOTO O

FIGURE 6

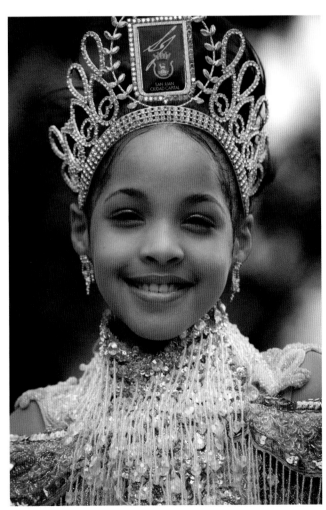

PHOTO P
I used the Sunshine filter to lighten this image and improve the subject's skin tone.

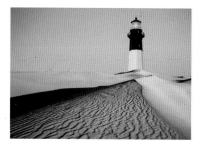

PHOTO Q

In the before **(PHOTO Q)** and after shot **(PHOTO R)** of the lighthouse and sand dune, I tweaked the parameters in the Sunshine filter to add contrast to this scene as well as introduce warm colors.

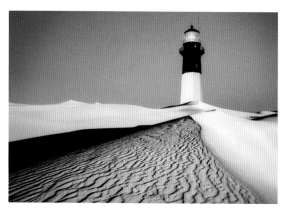

PHOTO R

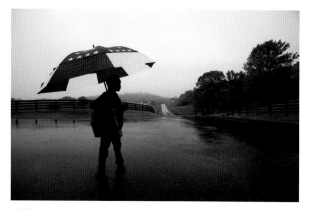

PHOTO S

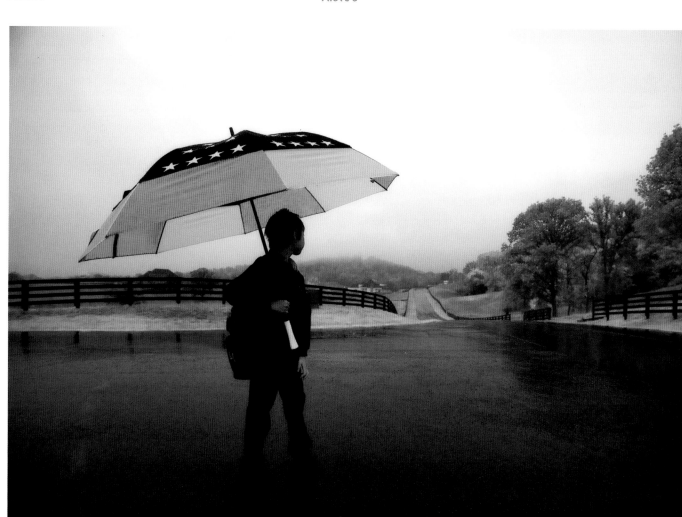

In **PHOTOS S** and **T,** I used Sunshine to add warmth to the very bluish morning. I like both versions, but notice how the umbrella really pops and how, even though it was lightly raining, the scene doesn't look as dreary as the original.

PHOTO U shows old rotting schooners that used to be an attraction in Wiscasset, Maine until they were removed in 1998. Originally photographed on film, I scanned the medium format transparency and then ran the digital image through the Sunshine filter. The contrast, grain, and color were all dramatically altered to produce an image **(PHOTO V)** that I feel is much more dynamic than the original.

PHOTO U

PHOTO T

PHOTO V
Use the Sunshine Filter to brighten and add warmth to dark images, as seen in **PHOTOS Q** through **T,** or go to extremes with the sliders and experiment with more dramatic effects to get images like **PHOTO V.**

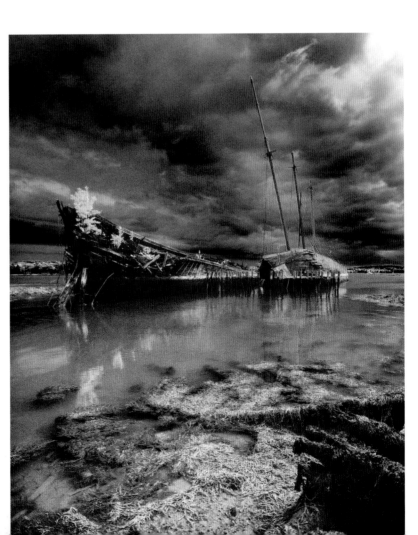

POLAROID TRANSFER

The technique of manipulating the emulsion of Polaroid film was very popular at one time, but with the rise of digital cameras, this instant film is becoming less available. The best way we can simulate the effect now is digitally.

Polaroid transfer prints are characterized by rough, torn edges, and sometimes an area of the image seems to be torn or scraped as well. This happens when the Polaroid emulsion has been removed from the paper backing during the development process when it is very thin, and is therefore vulnerable to damage. This look, however, is the point of going through the process. The colors are muted and they often have shifted toward a warm, yellowish tone. Nik's interpretation of the Polaroid technique is quite good, although it's still not quite the same. Nevertheless, it can produce some wonderful effects.

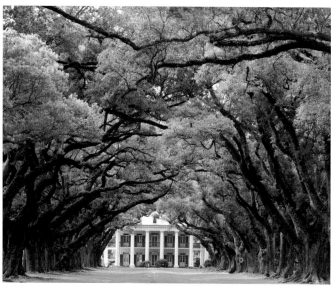

PHOTO W

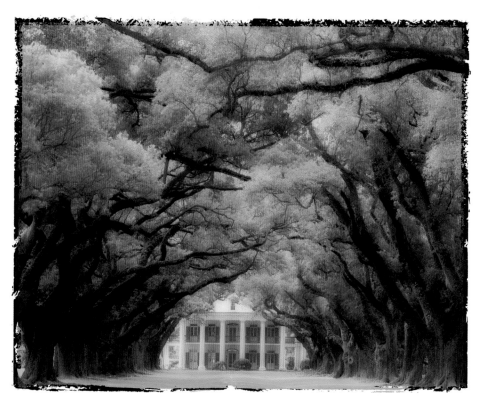

PHOTO X

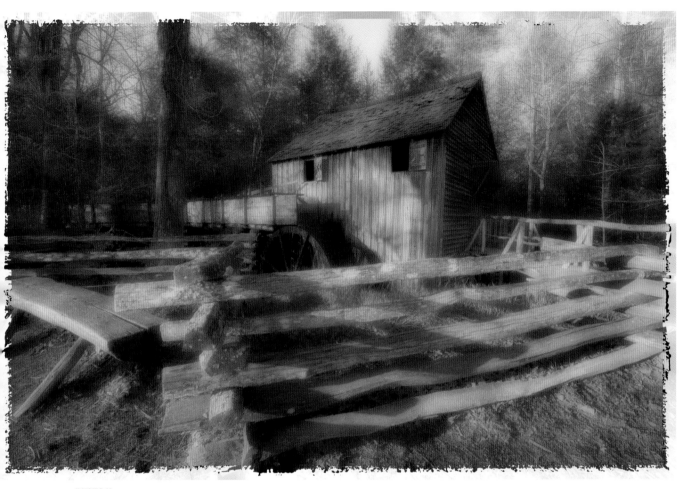

PHOTO Y
The Polaroid transfer filter simulates the rough edges and tweaked images from the days when photographers would remove the backing from Polaroid pictures before they were finished developing.

In the comparison **PHOTOS W** and **X,** you can see that a 'torn' border has been added (and you can change the width and character of this border) as well as the artistic abstraction of the photograph, which simulates what actually happens when making a Polaroid transfer. If the application of this effect doesn't abstract your photo as much as you'd like, you can always run the image through another Color Efex filter until you like the result.

PHOTO Y was taken in the Smoky Mountains National Park, and the Polaroid transfer filter gave this historic old cabin an ethereal glow as well as a border that is almost identical to the torn edges that you'd get by removing the Polaroid emulsion from its paper backing. I encourage you to experiment with this filter with many different kinds of subject matter because it has a lot of potential.

SILVER EFEX PRO
{ BY NIK SOFTWARE, INC. }

I n today's world of digital color photography, black-and-white images are starting to be seen less and less. However, one of the frequent questions I hear in my classes is about my preferred way to convert color images to black-and-white in Photoshop. Although there are many methods, one of my favorite ways is, without a doubt, to use Silver Efex Pro. This plug-in produces some of the most beautiful and authentic-looking black-and-white images that I have seen from any plug-in. It also has a beautiful interface that is extremely easy to use and encompasses many creative features. If you like black-and-white imagery, this addicting plug-in will fast become one of your favorite tools in Photoshop.

OVERVIEW

Often when I am shooting pictures, I know there's a chance I will convert them to black-and-white later. So when I am looking at a scene, I will pre-visualize what the final product will be in either black and white or sepia tone. Although some images might look very bland in color, converting them to a black-and-white picture can produce some very artistic results. Silver Efex Pro comes with an impressive list of built-in preset styles on the left side of the main window that let you pick and choose between some nice visual effects within seconds of opening the plug-in. The real power of this plug-in, though, lies in the perfectly laid out controls on the right side of the main window that let you design and tweak your image into many wonderful variations.

Silver Efex Pro helps turn color images into masterful black-and-white pictures. For this photo, it made the marine iguanas from the Galapagos Islands look like they were shot on old black-and-white film.

NEED TO KNOW

Website: niksoftware.com

Price Range: $ $ $ $ ○

Notes: Free 15-day trial available.

APPLYING THE FILTER

In the Filters menu in Photoshop, go to Nik Software>Silver Efex Pro. This will open a large and well-designed dialog box **(FIGURE 1)** that you can resize to your liking. I like to display it as large as possible, filling my entire screen.

The left side of the dialog box has a scrollable window of black-and-white preset effects. These are custom presets that come with the program and they include under- and overexposure choices,

pull and push processing, infrared film, high contrast, sepia tones, and more. This impressive menu displays large thumbnails that show exactly what your image will look like before you apply the effect. Scrolling through this large list gives you a pretty good idea of the many variations available. When you select a style you'd like to try, click on it and the change will be applied to the image in the large preview window to the right. If needed, a Preview button on the top of the dialog box lets you toggle between before and after views of the image.

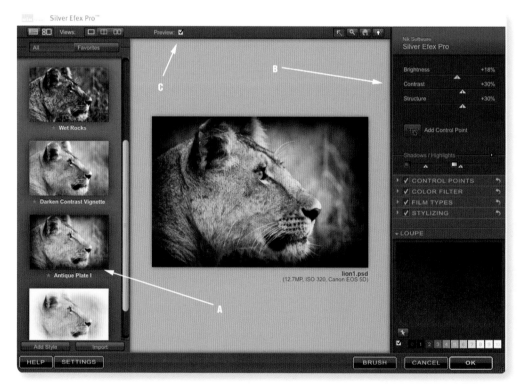

FIGURE 1

The Silver Efex Pro dialog box makes it easy to navigate through your black-and-white conversion options. The presets in the left column **(A)** offer various style choices, while the sliders at top right control the Brightness, Contrast, and Structure **(B)**. A preview button at the top of the window switches between before and after views **(C)**.

Fine-Tuning the Image

To get started, double-click on one of the presets. For the lioness in **PHOTO A,** I decided to use a sepia tone so I chose the Antique Plate 1 preset. After making the selection, go to the menu on the right side of the screen to begin altering your image and fine tuning it **(FIGURE 1).** The first thing that I do is work on the top three sliders: Brightness, Contrast, and Structure. The Brightness slider is one of the most important to use to get the exact shade or tone you want. The Contrast slider helps give a little punch to the image, while the Structure slider adds a lot of "edge" and is very interesting to play with. This slider can make your image very soft and smooth throughout or it can add a very gritty look. It's one of my favorite sliders in the plug-in and one that you will definitely want to experiment with.

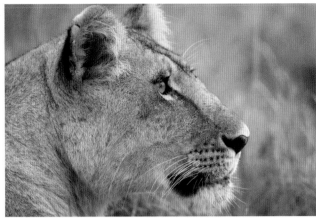

PHOTO A

FIGURE 2

Adjustable Control Points allow for an effect to be applied to specific areas in an image.

> **Note:** *The next sets of controls we'll cover are stacked in dropdown windows. To open or close these windows, click on the arrow next to the control name.*

Another key feature of this plug-in is the ability to add Control Points. These Control Points give users the ability to increase or decrease the Brightness, Contrast, or Structure amount to specific areas in the image **(FIGURE 2).** You can fine-tune any area in a picture, large or small, by using these Control Points. Applying them is easy; simply click on

the Add Control Point button, click a spot in the image that needs modifying, and then use the sliders that appear to control the size and other features of the Control Point. Once you have used control points and see how easy they make area-specific changes, you'll think controls like this should be included in many other plug-ins, too.

Below the Control Points are the Shadow and Highlight sliders. These are great sliders for opening up your shadow detail or taking down blown out highlights. These are helpful features that Nik has included in many of their plug-ins and they are extremely useful in Silver Efex Pro.

FIGURE 3
Use the Color Filter, Film Types, and Stylizing settings to design the individual look of each image.

FIGURE 4
Simulate the characteristics of a specific brand of film in your digital image by choosing from the Film Types options.

The next three settings are Color Filter, Film Types, and Stylizing **(FIGURE 3).** These are the settings that help design the individual look for an image. The first setting, Color Filter, simulates using colored filters over your camera lens if you are shooting black-and-white film (color filters are used to manipulate contrast, especially for situations like darkening the sky so white clouds stand out dramatically). As always, experimenting with these choices is the best way to get familiar with them and see how they change your images. Below the Color Filters are the settings for different Film Types **(FIGURE 4),** where you can choose different types of film, from the smooth look and feel of Kodak Panatomic X with an ISO of 32,

to Ilford XP 2 Super 400, or a grainy Kodak P3200 Tmax Pro film type. These film variations offer different textures and appearances and are a great way to alter an image. Below the Film Types are sliders for Grain, Sensitivity, and Tone Curve so you can fine-tune the look of the film type you've chosen.

Below the Film Type settings are the Stylizing settings. This menu contains three sub-menu options for Toning, Vignette, and Burn Edges. To see the options in these menus, click on the small arrows to the right of their names. The Toning menu contains color-adding presets in a pull-down menu that offer an incredible variety of choices, such as Split Tone, Coffee, Copper Toner, Selenium, and Sepia Tones **(FIGURE 5).** To preview these choices, simply hover over one of the options and

FIGURE 5

it will be applied to the preview image. Below the Preset pull-down are the Strength, Silver Hue, Silver Toning, Balance, Paper Hue, and Paper Toning sliders. These will allow you to not only get beautiful black and white tones, but subtle tones from gold to red to blue. The sliders essentially allow you to tone the image just like photographers used to do

in the darkroom, except that you have the ability to use an endless number of colors which can be applied with as much strength or subtlety as you want. You can also tweak the tone itself and the color of the paper separately.

Below the Toning menu is the Vignette menu. Nik has designed this to be very realistic, simulating the traditional look photographers achieved in the darkroom. In **PHOTO B** I changed the color image of the lioness into a beautiful, rich brown sepia-tone photograph with a vignette.

The Burn Edges feature allows you to darken the periphery of the image, simulating how many photographers presented their prints.

There are four tiny icons **(FIGURE 6)** that represent each of the four edges of your image. As you choose each one, the sliders below can be darkened individually. This gives you much more control than you ever had in the darkroom.

Each of the presets you create can be saved by clicking the + icon at the bottom of the preset preview window.

FIGURE 6

PHOTO B

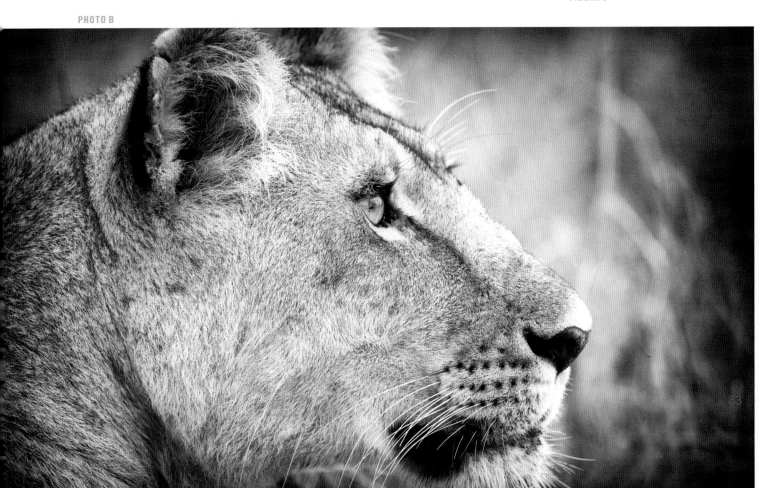

COMBINING BLACK AND WHITE WITH COLOR

Because Silver Efex Pro creates a new layer above your original color photograph, you can use the blend modes in Photoshop to combine them in various ways. The blend modes are accessed in the Layers palette as a sub-pulldown menu that has the default set to 'Normal'. You can also adjust the opacity of the layer so you will get a combination of both color and black and white. An example of this can be seen in the original autumn foliage photo taken in the Sierra Nevada mountains of California **(PHOTO C)**, and the two color/black-and-white combinations seen in **PHOTOS D** and **E.** I was able to manipulate the contrast as well as the color relationships simply by changing the blend modes and the opacity in the Layers palette.

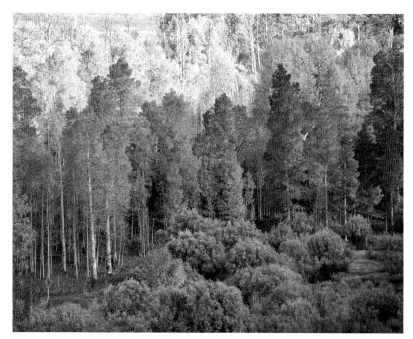

PHOTO D

PHOTO C

PHOTO E

In both photos D and E, the black-and-white versions of the images were combined with the original color picture using blend modes and the opacity slider in Photoshop.

SILVER EFEX PRO EXAMPLES

Silver Efex Pro also works beautifully on portraits of people, easily transforming color images into classic black-and-white photographs in seconds. By way of example see **PHOTOS F–H.** To begin, I chose the preset Infrared Film Normal. The resulting image of the subject, **PHOTO G,** looks very much like a traditional black-and-white infrared film image,

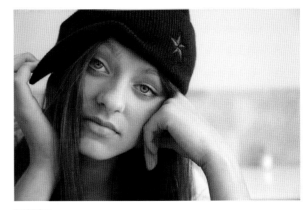

PHOTO F

PHOTO G

and the only change I made from the preset was to reduce the grain a little bit. Since this plug-in places the effect on a new layer, you can also create some beautiful hand tinted looks by reducing the opacity of the layer. In **PHOTO H,** I reduced the opacity of the Silver Efex layer to about 60%, which gave a very soft, muted look to the subject's face. The resulting image is the combination of the black-and-white infrared version with the original color portrait.

PHOTO H

Use Silver Efex Pro on portraits to get striking black-and-white pictures or subtle color images.

I used Silver Efex Pro on a wide-angle shot from underneath the Eiffel Tower in **PHOTO I.** I chose the High Structure preset and lightened the overall image just a little bit with the Brightness slider. Other than that, I did no other tweaking and the resulting image, **PHOTO J,** is a very striking black-and-white photograph that was very easy to create.

On their website, Nik has a tremendous variety of custom preset styles that users can download free of charge. These additional presets are categorized into Landscape, Portrait, Traditional, and Experimental categories and offer an even greater variety of effects to apply to your images. Silver Efex Pro is a plug-in that, in my opinion, is a must-have for photographers. It will produce consistent quality results that look and feel like traditional black-and-white or toned prints created in the days of the darkroom.

PHOTO I

PHOTO J

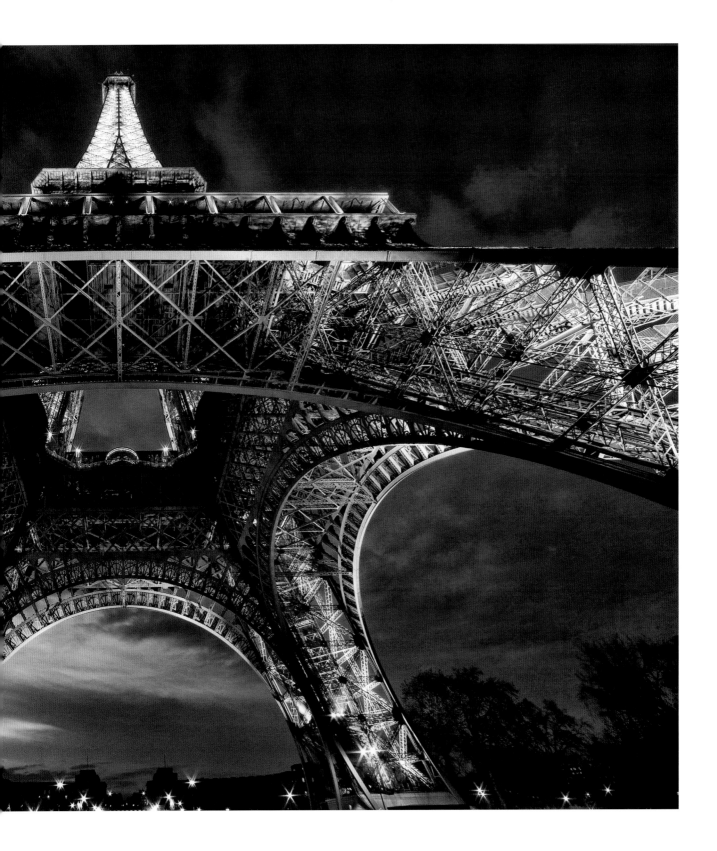

CHAPTER 3

Exposure 2, p90

Noise Ninja, p96

Digital Gem Airbrush Pro, p104

EMBELLISHMENTS

Enhancements that photographers in the past could only dream about can now be done almost effortlessly with Photoshop and plug-ins. Evening out the skin of a model to look as smooth as satin can now be easily done. Removing wrinkles and blemishes and taking years off a person is as easy as a few clicks of the mouse with Kodak Digital Airbrush Gem Pro. Forget getting years of experience, you will feel like an accomplished airbrush artist the first time you use this program. And if you're a portrait photographer, say goodbye to the need for a full-time makeup artist.

Noise Ninja is the industry standard plug-in for reducing or eliminating digital noise. It's a miracle tool that significantly improves images taken with a high ISO, even at 1600. Although this plug-in filter has a lot of controls, you'll be very satisfied with the results most of the time by simply using the default settings once Noise Ninja automatically profiles your photo. This one filter alone can change the way you think about the physics of photography. Lighting conditions that were a real limiting factor in the past are now far less of a concern thanks to Noise Ninja.

Do you still like the nostalgia of film? Do you miss the look of Kodachrome, Fujichrome Velvia, or Tri-X? You can simulate the unique character of dozens of films with Alien Skin Exposure. For true nostalgia fans, you can even introduce the look of real film grain into your pictures for images that truly harken back to the days of film.

EXPOSURE 2

{ BY ALIEN SKIN SOFTWARE }

One thing that many photographers miss when shooting digital is the look and feel offered by shooting film. Certain color and black-and-white films, such as Kodachrome, Fujichrome Velvia, and Kodak recording film, had unique characteristics that photographers employed, and they would choose one film over another depending on the style they wanted to create. With Exposure, Alien Skin has designed a plug-in that can replicate the look and feel of many of the most popular films.

THE EXPOSURE INTERFACE

When you select Alien Skin Exposure from the Filter pull-down menu, another menu appears offering the choice between Color or Black-and-White film. The main dialog box will open once this selection is made.

The dialog box, seen in **FIGURE 1,** is large and very easy to navigate. There are tabs on the top left for Settings, Color, Tone, Focus, and Grain. The main one we will look at first is Settings, which is the default tab. This is where you can go through the list and try out different film types to see what you want to start with. You will notice that there are many different varieties of films to choose from found in separate folders, such as Kodachrome 64, Polaroid Polapan, Fuji Reala, and many others from among the huge list. Click on the arrow next to a folder to reveal its options, choose one of the film types inside, and watch the immediate change in your image. If you want to toggle back and forth between the effect you just created and the original, hold down the Space Bar to see the original and then release it to see the effect.

FIGURE 1

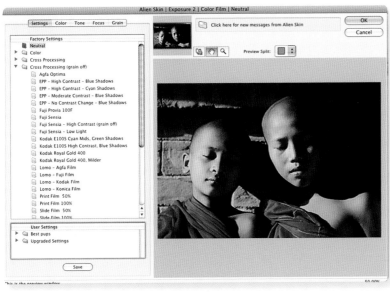

The Color tab is where you can alter the intensity of the image along with warming or cooling the colors (warming means introducing a yellowish color, while cool images have bluish tones). This is also where you can work on the saturation with the red, green, or blue channels individually, or you can increase or decrease the saturation of the entire image.

To the right of the Color tab is **Tone.** This is a very important part of Exposure; it is where you can adjust the highlight, midtone, and shadow details in your image. This is the place to add a lot of punch to your image.

In the next tab to the right, **Focus,** you can individually work on the focus of your highlight, midtone, and shadow details, which can produce some interesting diffusion-like effects.

The last tab is **Grain,** and it is one of the most powerful parts of Exposure. When the Alien Skin programmers were designing this plug-in, they used electron microscopes to look at the grain structure of many kinds of film. As a result, they were able to reproduce the look of film with remarkable accuracy. There are sliders for all aspects of grain, including its size and strength. There are roughness and color variation sliders, as well as sliders that simulate Push Processing (because when film is pushed, the grain structure changes). You have to work in this dialog box to really appreciate how powerful and unique this plug-in is. Grain is very different than digital noise. Many photographers like the effect of grain, but no one likes digital noise.

APPLYING THE FILTERS

For my first example, I chose a color photo of a lone tree in Africa with a dramatic sky **(PHOTO A).** This is the perfect kind of photograph on which Exposure can work its magic because the contrast between the beams of light and the clouds is fairly subtle. By the time I finish working within Exposure, the shafts of light will stand out much more and the effect will significantly enhance this image.

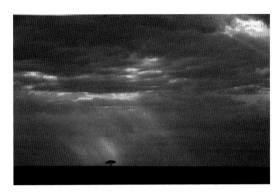

PHOTO A

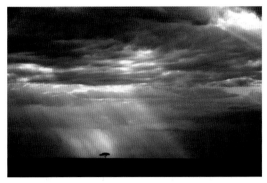

PHOTO B

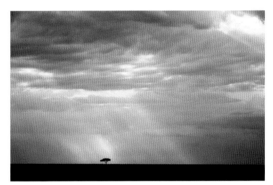

PHOTO C

Going back to the film choices in the Settings section, I selected the Cross Processing (grain off) folder and chose EPP–High Contrast–Blue Shadow. I like the way the image looks with this default EPP setting (EPP was a Kodak slide film), but I wanted to push it a little further. In the Color tab, I decreased the amount of bluish tone overall by moving the blue slider to −80 (SEE FIGURE 2). I also made the dark tones a little darker. In the Tone settings, all I needed to do was to move the shadow slider to -70 (FIGURE 3). It added a very nice richness to the image by manipulating the contrast.

PHOTO B shows the results of the EPP – High Contrast – Blue Shadow setting with the two small changes that I added. In PHOTO C, I chose another setting that is also in the Cross Processing (grain off) folder. It is called Kodak E100S–High Contrast –Blue Shadows, and it produced a completely different look with an overall light bluish tone. I also went in and changed two of the sliders in the Tone tab. I moved the Midtone slider to −30 and moved the Contrast slider to +40. This helped give the image even more impact than the default E100S setting. Obviously, picking a film type is only the beginning. After you find one that looks good, go and have fun adjusting all of the sliders and controls to get exactly the look and feel that works best for that particular photo.

FIGURE 2

FIGURE 3

93

My favorite part of Exposure is the ability to save a particular setting you like as a preset. All you have to do is hit Save on the bottom left underneath the User Settings window, and it brings up a dialog box where you can save your presets into an existing or new category. I save these presets with unique names to remind me of the photograph that I used it on. When working on future photos in Exposure, you can search through your own presets first to see if they add the kind of artistry you are looking for.

PHOTO D

FIGURE 4

BLACK AND WHITE

Exposure has an incredible Black-and-White mode that replicates an amazing variety of films and can add some great black-and-white or sepia-tone effects. Along with many traditional film types, there are several impressive infrared films as well as specialty films like Polaroid Polapan. When you choose Black and White Film from the Exposure pull-down menu, it opens a dialog box that looks identical to the Color one, except it has only black-and-white films in the settings box. It also has different slider options when you click the Color tab. You can add color to an image for making toned images like sepia, selenium, etc.

For **PHOTO D,** a photo I took in Burma, I wanted to add a sepia tone for a classic fine-art look. With the image open, I scrolled through the film choices and went to the Color Toning folder.

The last option in this folder is called Warm Brown **(SEE FIGURE 4)** and it produces a classic sepia color that is very similar to what darkroom photographers created when making prints the old-fashioned way. The first thing

PHOTO E
By Choosing the Warm Brown option from the Color Settings folder and changing a few of the settings, I was able to create this dramatic sepia tone image.

I did after selecting Warm Brown was to go to the Color tab. The image seemed a little dark and also a shade too brown, so I moved the Ink Strength slider down from 100 to 80. This removed a little of the color. I next went to the Tone tab and moved the midrange slider up to +15 to lighten the image a little, thus opening the shadows and reducing the contrast. Finally, I used the Grain slider to introduce additional grain to really reproduce the look of film, as seen in **PHOTO E.**

DOWNLOADABLE PRESETS

In my picture of the Eiffel Tower **(PHOTO F),** I wanted to add some impact and bring in the beautiful cobalt blue sky from my 5-second exposure. I decided to use one of the optional presets that you can download from the Alien Skin website. They have additional presets in color and black and white for anyone to download and use, and it takes only seconds to add them to your list of presets.

(To find these presets, go to alienskin.com and then click the Support tab. In the pull-down menu, choose Forums and you'll see a list of products. Choose 'Exposure 2' and that will reveal all of the available presets.) In the Color settings, I chose the Winter Morning Harsh preset and although it looked very nice, I decided to open up the Midtone slider to make the image brighter and have the blue become bolder. I moved the Midtone slider up +30 and it gave me exactly what I was looking for. You can see in the final image **(PHOTO G)** how the overall intensity and colors of the tower and the sky are dramatically changed.

Alien Skin Exposure is an amazing plug-in and can give your images a very unique look that is not so easy to replicate in Photoshop. You can create all kinds of variations and save them as custom presets to use over and over on many types of images. The more you play with Exposure, the more you will count on it when you need to add some very special effects to your photographs.

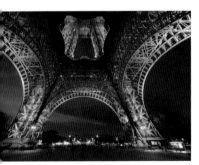

PHOTO F

PHOTO G
I used a downloadable preset from the Alien Skin website to find a filter that really helped this image's colors pop from the page.

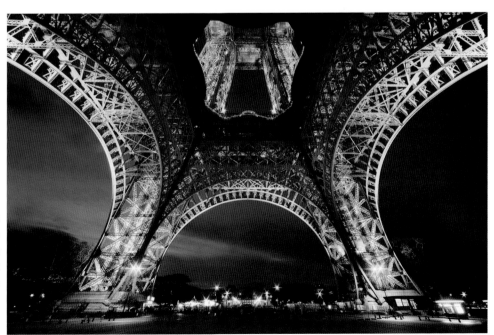

NOISE NINJA
{ BY PICTURECODE }

Noise reduction software has been around for a long time in Photoshop, and it is also built into many digital cameras. Noise is usually an undesirable consequence of shooting in low light or fast-action situations, and most photographers don't like it. Although there are other options for reducing noise, the gold standard in the photo industry is Noise Ninja.

OVERVIEW

Any time you shoot at an ISO higher than 100 or 200, you have a much better chance of introducing noise into your image. In many kinds of shooting, including news, sports, wedding, and wildlife photography, where a high ISO is often needed, the resulting noise can significantly degrade the image quality. Noise is also a problem when taking long exposures. Noise Ninja can easily bring back a two-f/stop improvement while preserving much of the important details in the image. You can even improve lower ISO images by making them cleaner and smoother than they were to begin with.

Noise Ninja has a powerful set of tools, including automatic and manual noise analysis, camera-specific profiles, an innovative Noise Brush, and batch processing. The program can be operated using a one-button automated approach, or you can take advantage of the many manual choices and have full interactive control. The result is an unprecedented balance between noise suppression and detail preservation, creating natural-looking results without any artifacting.

Another great feature of Noise Ninja is its auto-profiling capability. PictureCode offers downloadable profiles for dozens of digital cameras on its website; once installed, Noise Ninja will use these profiles on your images to do a remarkable job at reducing or, in some cases, virtually eliminating noise. For unlisted cameras, profiles can be created in a few minutes using a simple chart and the push of a button.

NEED TO KNOW

Website: picturecode.com

Price Range: $ $ – $ $ $ ◯ ◯ depending on chosen package

Notes: The trial software is an unlicensed version that overlays a grid on the image until a license is purchased.

THE NOISE NINJA INTERFACE

In **PHOTO A,** I took a shot of the Oakland Bay Bridge with San Francisco in the background at night with a 15-second exposure. Long exposures like this are notorious for introducing a great deal of noise, and when this picture is enlarged by just 50%, the noise is obvious in the darker areas of the image **(PHOTO B).** Noise Ninja is accessed by going to Filter>Picture Code>Noise Ninja. This brings up the very large dialog box **(FIGURE 1),** which has a lot of buttons, tabs, and sliders, but after using the filter a few times you will quickly understand this easy plug-in. Once the dialog box has been set to your preferences, using Noise Ninja can be as simple as opening your image in the plug-in and pressing OK.

What I like most about the Noise Ninja interface is that you can move the small green box (which appears over your image by default) anywhere you want over the large preview and this gives you an almost microscopic look at the noise in your image. This allows you to see what's really going on with respect to digital noise, and it allows you to make intelligent choices in reducing its impact.

PHOTO A

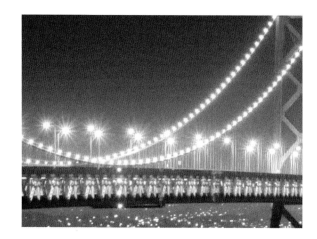

PHOTO B
A close-up of the bridge photo reveals a considerable amount of digital noise.

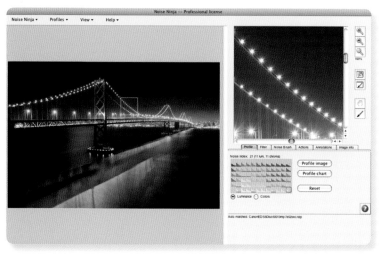

FIGURE 1
Although this dialog box shows many options for tweaking noise, once you have settings in place for your camera, the filter becomes very efficient to use.

The close-up at left shows the digital noise evident in the original picture. The image at right shows how much smoother the image appears after noise Ninja is applied.

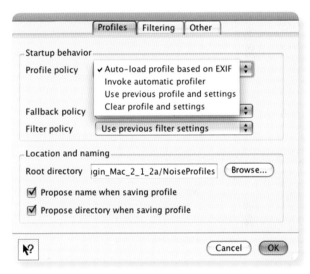

FIGURE 2

Preferences: Loading Profiles

On the top left of the dialog box, under the Noise Ninja pull-down menu, is where the plug-in preferences can be found. The first (and default) tab displayed is Profiles. Here you can use the camera profiles that you have downloaded from PictureCode's website. To install camera profiles, follow the instructions on the Profiles webpage (www.picturecode.com/profiles.htm) for downloading and installing your camera's profiles. Once they are installed, you will know the profiles are being used by the software by looking at the 'Location and naming' portion of the Preferences dialog box. Here you will see the words 'Root directory'; click on the Browse button and look at the new dialog box that appears. If your camera's name is listed in a subfolder under the Noise Profiles folder, then Noise Ninja is set up to use your camera's profiles.

An easier option is to let Noise Ninja Auto-load your profile based on your camera's EXIF data. Using this option, the plug-in finds and loads the profiles for your images automatically. To auto-load the profiles, go to Preferences and choose 'Auto-load profile based on EXIF' from the Profile Policy pull-down menu (SEE FIGURE 2). You'll know the profile has been loaded when you see the name of your camera (along with other information) appear above the Load and Save profile buttons (which look like a folder and a disk) in the bottom of the dialog box.

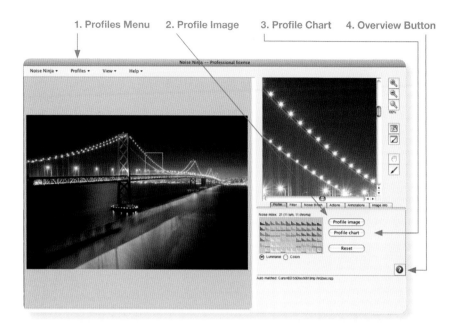

1. Profiles Menu 2. Profile Image 3. Profile Chart 4. Overview Button

Next to the Noise Ninja pull-down is the Profiles menu **(1)**; this is where you can load, reset, and install your profiles. It is all very easy to do and this is where you can fine-tune Noise Ninja for your particular camera(s). Choosing 'Load profiles' from the pull-down menu lets users select a profile that has been previously saved, and then it will be the active file used. The 'Install profiles' option lets you select a folder that has many kinds of profiles in it, including profiles a friend might have sent you, and Noise Ninja will copy it into the 'noise profile folder' that is configurable in the preferences dialog box. If you downloaded camera profiles from PictureCode's website, don't worry; they are automatically installed in the software, so you don't have to save them with either of these commands.

There are two large buttons in the dialog box called "Profile image **(2)**" and "Profile chart **(3)**". The Profile image button will create a profile

automatically from the current image. This is a useful tool if you are working quickly and don't have time to create a suitable profile, but be aware that the software can be fooled by excessive highlights and shadows in the image. The Profile chart button is used to create a profile from the profiling chart included with the Noise Ninja files. I don't use this button because I don't find it useful.

Other Tools

A great feature that PictureCode has included in this plug-in is the Overview button **(4).** This looks like a question mark in a blue circle. Click this and it explains the features for the section of the dialog box you are working in. Many of the other icons will be familiar to you, like the magnifying glass and the hand tool. For the tools that are not familiar, simply hold the cursor over that icon and in a second or two you'll be able to read what it does.

APPLYING THE FILTER

Noise Ninja supplies a 30-second guide to using the software in the help guide (at the top of the dialog box, go to Help>User guide). This can be useful for getting the basic gist of the program. Really, using the software is as simple as the following:

1. Click on the Profile Image button on the Profile page. This will measure the noise in the image, and this is how the software determines what needs to be tweaked.

2. Adjust the Luminance Strength slider on the Filter page until you are satisfied with the results.

3. Go to the Noise Brush tab. Paint with the brush tool in the Preview window to protect the parts of the image that you don't want to be affected by the filter.

4. Press the OK button to apply the filter to the image. This procedure should produce reasonable results for many pictures. However, you will have more control if you learn to use more advanced features like camera profiles, automatic profile loading, and actions.

You don't always have to use the Noise Brush. You can apply Noise Ninja to the entire image and use a layer mask to paint in only the areas that need it. As mentioned before, layer masks are the key to using many of the plug-ins in this book (see page 10), and I use them all the time with Noise Ninja. To get deeper into the other settings and sliders, you can use the Help menu, which is well written and very useful.

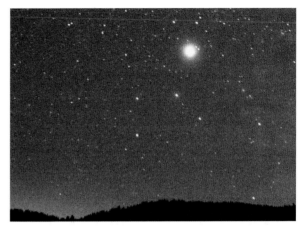

PHOTO C

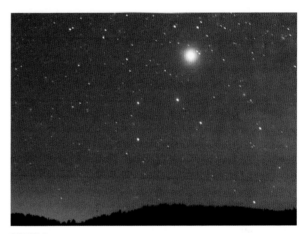

PHOTO D

Noise Ninja can be used very quickly and it will drastically reduce obvious noise, as seen in these before and after photos of the night sky.

To illustrate the dramatic difference between an image taken at ISO 3200 with and without Noise Ninja, compare **PHOTOS C** and **D.** The original photo was taken under the stars at ISO 3200 with a 25-second exposure. The combination of high ISO and long exposure guaranteed a photograph with lots of noise. **PHOTO C** shows an enlargement of the original image, and it is easy to see the high levels of digital noise. **PHOTO D** shows the same image after Noise Ninja was applied, and the difference is remarkable.

Noise Ninja also works very nicely on black-and-white images. I applied it to the image of the woman in **PHOTO E.** This image was originally shot with film and had a fair amount of grain, so I had to increase some of the settings manually in Noise Ninja to smooth it out. In **PHOTO F,** the close-up reveals a large amount of noise on the subject's forehead, chin, and on the right side of her face. Under the Filter tab is where you can manually increase or decrease the Luminance noise in an image. In **FIGURE 3,** you can see where I increased the Strength and Smoothness sliders from the default of 10 to 13. This made a dramatic difference and gave the subject an overall smoother look.

The final picture **(PHOTO G)** shows the improvement that Noise Ninja made on the entire image by decreasing the noise levels substantially.

FIGURE 3

Noise Ninja works well on pictures of people as well. The close-up **(PHOTO F)** shows a lot of distracting noise, so I increased the Strength and Smoothness sliders in the dialog box to achieve the cleaner look in **PHOTO G.**

PHOTO G

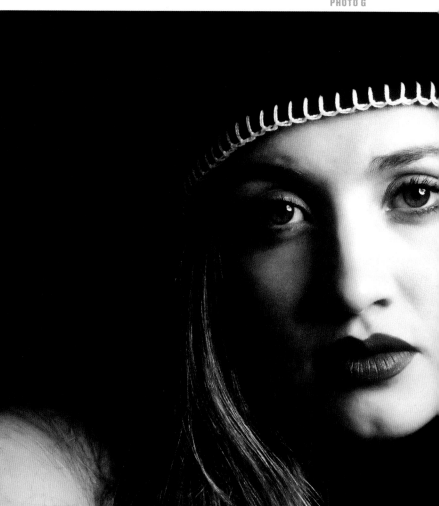

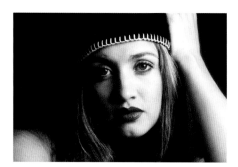

PHOTO E

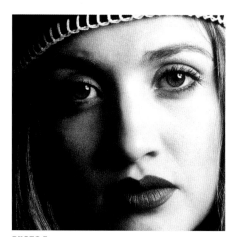

PHOTO F

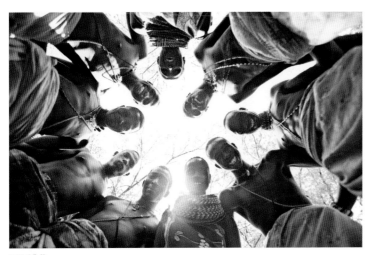

PHOTO H

PHOTO I

PHOTO J

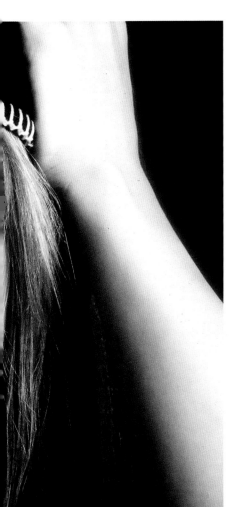

The above example shows where I used Noise Ninja in a shot of the Samburu Tribe in Kenya **(PHOTO H).** Shooting up at them from the ground, I set my ISO to 400 and had to open up the exposure to make sure their faces were not underexposed. Looking at a close-up of their faces in **PHOTO I,** you can see that the noise level needed a little help. I let Noise Ninja do its auto-profiling and the result shows a nice decrease in the colored noise across their faces **(PHOTO J).**

One of the advantages of Noise Ninja is being able to shoot at higher ISO settings when you need the additional speed but do not want to compromise the image with extra noise. With noise being less of a concern, you can shoot in darker situations at higher ISO settings and use a faster shutter speed, thus insuring that your images will be sharp. From film to digital images, Noise Ninja can fix a variety of noisy images in a matter of seconds.

103

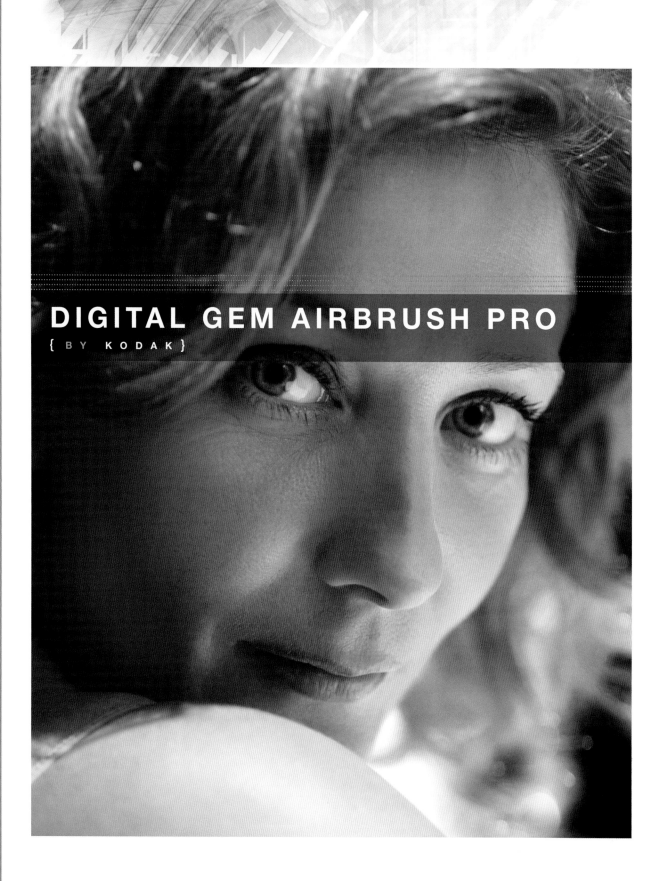

DIGITAL GEM AIRBRUSH PRO

{ BY KODAK }

Kodak Digital Gem Airbrush Pro is one of the best plug-ins for making your subjects look like they have makeup professionally applied. It provides a quick and powerful way of smoothing skin without blurring or affecting the detail of important facial features. I have used this plug-in for many years and I cannot tell you the difference it has made in countless numbers of my images. It is the closest thing I've ever seen to having your own makeup artist with you while you're shooting.

NEED TO KNOW

Website: asf.com

Price Range: $ $ ◯ ◯ ◯

Notes: A 30-day free trial is available from the asf.com website.

OVERVIEW

Whether it is wrinkles, blemishes, or blotchy skin, this plug-in offers meticulous airbrush effects without a lot of masking or manual softening. It smoothes surfaces in digital images by reducing harsh shadows and highlights, and it minimizes imperfections on skin while fully preserving details like hair, eyelashes, eyebrows, and the true character of the subject's face. It is extremely easy to use, and after having your sliders set up in the program the way you want, you can just open up the dialog box and hit OK to apply the effect you have chosen. There really is nothing else like this plug-in; it's a must-have for anyone who wants to retouch faces or smooth skin anywhere on their subjects' bodies. For any amateur or professional portrait photographer who wants to show a subject at their most beautiful by reducing distracting imperfections, this plug-in should be strongly considered.

Opening the program from the Filter pull-down menu reveals a simple and easily mastered dialog box (**FIGURE 1**). The right side of the dialog box shows all of the controls as well as a small preview window used to navigate around the image. Wherever the red box is placed, the bigger preview window at left displays that part of the image. The default settings in the dialog box work pretty well, so you don't need to change them too much.

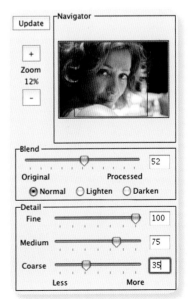

FIGURE 1
The dialog box for this plug-in is simple to use and its settings will have a dramatic affect on improving the smoothness of your subjects' skin.

MODIFYING IMAGES

PHOTO A shows a close-up portrait. The picture could use some subtle work to give the subject's skin a smoother look. I set the Blend slider to 52, which does a nice amount of smoothing without exaggerating too much. This amount will probably work fine for most images. Below the Blend slider are three radio buttons affecting brightness in the image. I chose Normal, which is also a good default setting. Below that are the Detail sliders, and for those I left Fine on 100, Medium on 75, and Course on 35 **(FIGURE 2).**
Sometimes these settings need to be tweaked, depending on the effect needed for a particular image. What you will want to pay attention to is how smooth the skin looks, how defined any wrinkles are, and whether or not blemishes have been eliminated. Click the Before and After buttons to compare the original with the effect you have added.

For how easy this program is to use, the results are very impressive. Trying to achieve these effects any other way in Photoshop would definitely require a lot more work than just adjusting a couple of sliders. You can see in **PHOTO B** what a difference the plug-in made; the model's skin is much softer and even across her face,

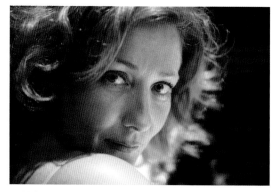

PHOTO A

as if a makeup artist had been working with us on the shoot. This plug-in does a great job without softening the eyes or eyelashes too much, but you can also use a layer mask and paint back in the eyes, eyelashes, eyebrows, and even the lips if you want. You can also use a layer mask to paint back in the hair, which often becomes softer when using this plug-in. (See page 10 for using layer masks.)

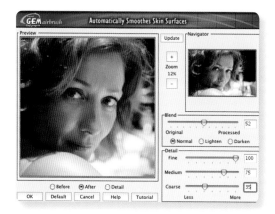

FIGURE 2

PHOTO B

PHOTO C

PHOTO D

This plug-in also works extremely well on men and can help smooth out even the roughest kind of face. In the picture of the male model in **PHOTO C,** you can see that his skin has a rough quality to it that is appropriate for a masculine portrait. But if a younger look is desired, this plug-in can work perfectly. Using the settings from above, I changed the blend mode to 70 to make it a little stronger. The final image, **PHOTO D,** shows how effective this technique works on men as well. The only subjects that get little benefit from this plug-in are babies and children whose skin doesn't need much help for the most part. Also, anyone that has had his

or her makeup expertly applied before the photo session might not need the help of this plug-in.

One thing I also like about using this plug-in is that it can really help with the shine on faces that is caused by oily skin. Bright highlights on faces or on any other part of the body can be very distracting and unflattering to the subject. Using this plug-in is a great way to help reduce shine easily and quickly. This is one plug-in filter that I recommend adding to your arsenal if you want to get better at retouching people and making them as attractive as possible.

CHAPTER 4

PhotoFrame Pro, p110 Snap Art, p118 FocalPoint, p126

GLITCH IN THE MATRIX

Much of photography is pre-visualization. However, we often don't see the best approach to an artistic interpretation of a subject until after the fact. One of the things that is constantly an issue for photographers is the point of focus and the depth of field. Is the background blurred enough, should the depth of field have been more shallow? After leaving the scene, it's often hard to go back to get another shot with more interesting depth of field. That's where FocalPoint comes in. Now, there's no need for remorse or trying to recreate the right conditions. FocalPoint allows the plane of focus to be tweaked in many ways, and this has never been available to photographers in the past. It's an innovative tool that you will find irreplaceable in your creative arsenal.

Snap Art lets you turn your images into fine art. You can simulate dozens of painting and drawing styles simply, and endless modifications are possible with the program's detailed controls. If you've ever felt that there is a visual artist hiding within you, this plug-in will allow you to experiment and explore creating fine art images without spending hours in front of a drawing board or canvas.

What does every perfect, finished photograph need to make it great? A complimentary frame, of course. A good frame can dress up, dress down, or transform the feeling of an image. PhotoFrame allows you to create personalized frames for your work or choose from thousands of presets. You can combine frame styles and tweak the size, texture, color, shape, and design to create a signature frame that adds the finishing touch to any work.

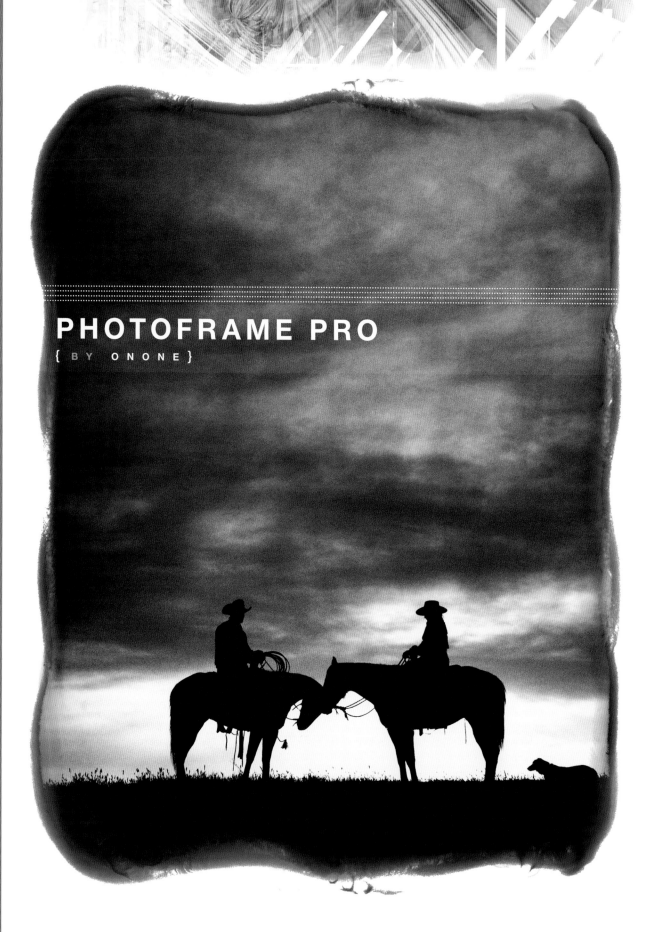

PHOTOFRAME PRO

{ B Y O N O N E }

To create a unique edge and border effect around your photographs the old-fashioned way (in the darkroom), you had to buy extra negative carriers and use a metal file to cut into the edges of the window into which the negative was placed. The imperfect metal edges would then let light pass onto the photographic paper and give you an abstracted frame around the photo. These edges, which were called sloppy borders, provided alternatives to straight lines and gave prints a different look and feel. Now fast-forward to today, when we can easily recreate these effects (plus thousands more) in Photoshop using PhotoFrame Pro.

NEED TO KNOW

Website: ononesoftware.com

Price Range: $ $ $ $ $ +

Notes: A trial version of the software is available at onOne's website.

OVERVIEW

PhotoFrame lets you choose from over 4,000 professionally created edge effects for your images. You can add almost any kind of artistic border, such as torn paper, watercolor affects, brushstrokes, film sprocket edges, and even realistic frames and mattes. I have been using this plug-in since it first came out years ago and I'm still amazed at all of the beautiful variations available with each style of frame. With the Pro edition, even more custom frames designed by top professional photographers are available.

One of the software's best features is the Frame Browser, which previews all of the frames and mattes in a scrollable window **(FIGURE 1).** This is an efficient way to see all of the available frame options at a glance. The pull-down menu above this window is set by default to All, which displays the entire list of frame options (if you are using the demo version, less frames are available). However, different border themes can be selectively displayed by choosing a different volume from this menu.

FIGURE 1
This is the dialog box for PhotoFrame Pro, which is a very useful program for applying borders and frames to digital photos. The column at left shows thumbnail previews of the available frames and border effects.

Some photographers create a unique custom PhotoFrame as the signature for many of their images. Making and saving custom preset frames is very easy and they can include custom drop shadows, borders, textures, colors, bevels, blurs, and glows. Each frame's features can be modified to produce the precise look and feel you want. It's even possible to combine several frames together and alternate the background color of each one to create the illusion that you developed the picture using traditional darkroom techniques **(PHOTO A).** We'll get into the details of how to make custom frames a little later.

APPLYING A FRAME

To get started, choose a picture you want to put a frame around. I felt that the sepia-toned infrared shot of Angkor Wat in Cambodia **(PHOTO B)** would look good with a frame, so I opened it in Photoshop. To open Photoframe, go to Filter>OnOne>PhotoFrame. A large dialog box will open, displaying your image and three palettes. When the plug-in is opened, the last frame that you chose from a previous session will be displayed on the selected photo (unless the program is being used for the first time). On the left side of the dialog box, find the Frames palette

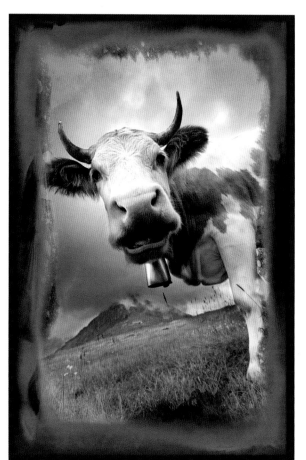

PHOTO A

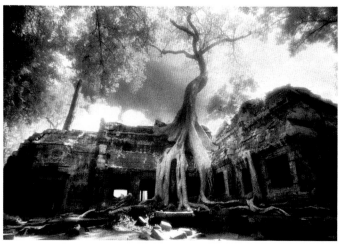

PHOTO B

FIGURE 2

Click on the All pull-down menu to reveal volumes of frame sets. Each set contains numerous frames in many styles.

(it appears in a group of three tabs that also include the Textures and Presets palettes), and click on the All pull-down menu. When you click on any of the volumes that appear, you'll see a submenu of frame sets that have been given names like brush, camera, canvas, charcoal, etc. **(FIGURE 2).** Each set contains a large number of frames. Spend some time scrolling through the volumes and sets of frames, familiarizing yourself with the choices until you find one you'd like to try. When you select a set, previews displaying each frame will appear in the window below. You can see all of these frames in a larger window by clicking the View Frame Grid button at the top of the Frames palette **(FIGURE 3).** This window is very useful for deciding on the best frame because it displays a large preview of nine frames at a time **(FIGURE 4),** giving you a better idea of how each frame will look surrounding your image.

I chose the frame 'brush 07' (from Volume 1, sub-group 'brush'), which can be seen in **FIGURE 5.** Double clicking on this frame's icon in the Frame palette preview window makes the frame appear on the photo in the main display window. When you select a frame, choose the button in the lower right corner of the dialog box Apply to New Layer. This allows you to delete or modify the layer in the Layers palette in Photoshop. By clicking the eye icon in the Layers palette, you can also turn the frame's visibility off and on to see if you really like it.

FIGURE 4
Frame Grid view allows you to see your picture with many frame options applied.

Click the View Frame Grid Button to see your images in Frame Grid view as shown in Figure 4.

FIGURE 3

FIGURE 5

Modifying the Frame

Once the frame has been applied, you can work on the background, border, bevel, glow, and shadow using the tabbed palette on the right side of the screen to alter the look of the frame **(FIGURE 6)**. The tabs and sliders in this palette allow you to reduce the opacity, increase the blur, change the color, and do many more things to personalize the selected edge effects. To use the Background tab, a background must first be chosen using the Textures tab from the palette on the left side of the screen. Experimenting with these palettes is the best way to understand what they do. For some of the palettes to work, you must click the On button found in the bottom of the palette **(FIGURE 7)**.

In addition to these controls, you can also shrink or enlarge your frame by clicking on it in the preview window and modifying it using the handles. For an extra creative twist, try grabbing one of the handles from any corner and turn your frame around in a circle to reposition it.

If you have developed a frame with settings you want to use again, PhotoFrame can save it as a preset; just go to File>Save Settings. Create a list of your favorites that can be seen under the 'Preset' tab so that you can go right to them whenever you want. Later, when you open a new photo and want to apply a preset, go to the Presets tab, and in that palette, double-click on the name of the frame you want to use.

When you are satisfied with the frame you've created and customized, click Apply to New Layer. The frame is then added to the original image on a

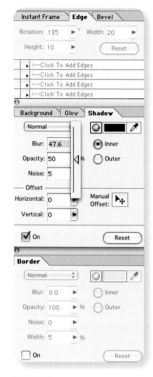

FIGURE 6

This palette, with its multiple tabs and sliders, can make many adjustments to personalize your frame or border.

FIGURE 7

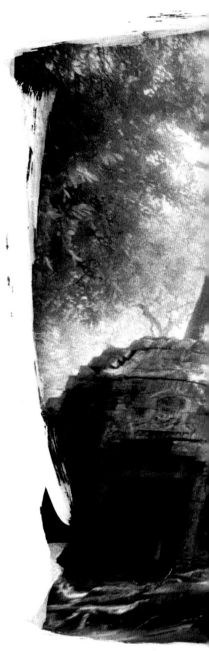

duplicate layer so it can be easily modified or deleted without harming the original. **PHOTO C** shows the frame I placed around the image of Angkor Wat.

PHOTO C

A personalized border can add the perfect finishing touch and help convey your image's intent.

FRAMING EXAMPLES

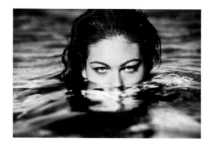

PHOTO D

PHOTO D shows a model I photographed in the ocean. Let's see what this photo looks like with one of my favorite frames. From the list of volumes, I selected the Realistic Frames set and then opted for the category Film 35. This gave me a selection of frames that look like 35mm film. Scrolling down the list, I chose the third frame **(FIGURE 8)** and positioned the film sprockets at the top and bottom of the image. The resulting image simulates a piece of 35mm slide film **(PHOTO E)**.

FIGURE 8

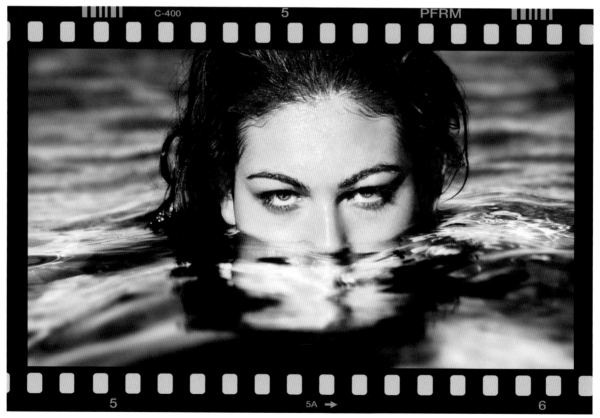

PHOTO E

PhotoFrame includes interesting options in the Realistic Frames set, like this 35mm slide film frame.

One of my favorite pictures can be seen in **PHOTO F;** it is a Western scene of a cowboy with his horses by a lake. To add a custom frame to this photograph, I chose one of the optional frames that you can buy online from the OnOne website. Their custom frame packs can be installed in seconds and offer a variety of frame choices. Jack Davis, a master Photoshop technician who has designed some of my favorite frames, designed this set. For this image, I chose the frame Davis_Frame-09i. It added a very interesting soft edge to the image that looks like paint strokes **(PHOTO G).** I pushed and pulled the handles in the main window to leave an equal amount of white space around the image, and then clicked OK.

PhotoFrame is a well-thought out plug-in that continually impresses me with every new upgrade. With thousands of frames to choose from combined with the endless numbers of effects, this plug-in offers countless possibilities for adding creative frames to your images.

PHOTO F

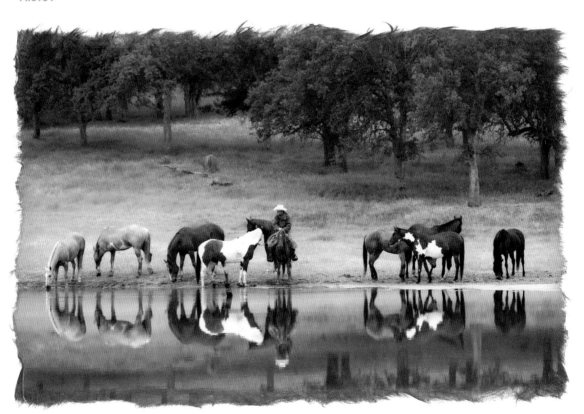

PHOTO G

The onOne website sells extra sets of frames designed by professional photographers and graphic designers, including the border seen on this image.

SNAP ART

{ BY ALIEN SKIN SOFTWARE }

One of the most exciting plug-in filters I work with is Snap Art, made by Alien Skin Software. Few Photoshop plug-ins can simulate classic painting and sketching styles as well as Snap Art, which requires a minimum of effort to use. A few tabs and slider bars are the only things needed to rework your photos into classic-looking works of art. And with many styles to choose from, you'll be feeling like an artist in no time.

NEED TO KNOW

Website: alienskin.com

Price Range: $ $ $ ○ ○

Notes: The Snap Art demo is active for a 30-day trial period.

WORKING WITH SNAP ART

To access Snap Art, go to Filter>Alien Skin Snap Art; a dropdown menu will appear with a list of choices including Color Pencil, Comics, Impasto, Oil Paint, Pastel, Pen and Ink, Pencil Sketch, Pointillism, Style, and Watercolor **(SEE FIGURE 1)**. Each one of these artistic filter options can produce amazing works of art and you should try all of them at some point while experimenting with this plug-in. For now, choose any one of these options to follow this tutorial; once selected, the Snap Art dialog box appears, and the default settings for the chosen filter will be applied to your image in the large preview window. At the top left of the dialog box there are five tabs: Settings, Basic, Colors, Canvas, and Lighting **(FIGURE 2)**. These are the main portals into the many control options within each painting style that Snap Art offers.

FIGURE 1

Select a Snap Art style from the pull-down menu to open the plug-in's dialog box.

FIGURE 2

The five tabs seen at the top-left of the dialog access Snap Art's settings palettes.

119

Settings Tab

When you click the Settings tab, there are about 25 to 30 different preset brush types available and, in some cases, a background material you can choose from **(FIGURE 3).** These choices cover the gamut from soft, delicate strokes on canvas to abstract strokes in pastel colors. At first, I would recommend going with Factory Default until you explore the other ways to affect the photo with the other dialog boxes. The Factory Default setting is quite good—the brush strokes are very realistic and they do a superb job at simulating various painting or sketching techniques. After you gain some familiarity with how to use the other controls in the program (which we'll cover momentarily), come back and experiment with the different styles in the Settings tab. There will probably be a style choice for just about any kind of look you are going for, and you can then modify it further with other controls, like those found in the Basic tab.

FIGURE 3

The Settings tab offers selections for brush and canvas styles.

FIGURE 4

The Basics tab is where the brush strokes are modified using the available sliders. In the bottom-left corner of the dialog box, a description of each slider appears as you hover over the control **(A).** If needed, use the magnifying glass to see the change in the brush settings up close on the image **(B).**

Basic Tab

When you click on the Basic tab you will see the first group of slider bars that really define the look of your painting **(FIGURE 4).** This dialog box allows you to change the length and width of the brush, the thickness of the paint, and the amount of coverage (which specifies how much of the image will be covered by strokes and how much will show a solid background color). Notice the text along the bottom left edge of the dialog box **(A).** Every time your cursor moves over a slider bar or any other control, Alien Skin cleverly provides an explanation for what it does to your picture. Of course, reading an explanation isn't the same

as seeing the actual effect, but this gives you a quick description that is helpful in describing what a particular command will do. If you want to see a close-up view of the image, use the magnification tool **(B).**

Colors Tab

When you choose the Colors tab, you will see familiar slider controls. Saturation, Contrast, and Brightness can best be controlled in Photoshop, but Snap Art does a very good job at allowing you to alter these effects here, too. Using the Color Temperature control is like putting a blue or yellow/orange filter over the lens to cool down or warm up the image. Personally, I never use this slider. The Random Color Variation slider introduces other colors into the picture, and I find this to be a creative tool that can significantly alter the look of an image. The additional colors help make the final image look more like a piece of artwork.

Canvas Tab

The Canvas tab gives you three more options, this time with respect to the actual texture and pattern of the "surface" on which you are painting. The pull-down submenu Canvas Texture offers many choices for the kind of canvas or paper texture your picture could have, and with the slider bars you can increase the thickness and the size of the pattern.

Lighting Tab

The Lighting tab allows you to change the direction of the light in your painting. By clicking on the highlight on the sphere icon, you can move it around until you like the angle. A more severe angle reveals more of the painting's texture by highlighting each minute rise in the canvas or paper material. For some paintbrush strokes and styles, the lightning effect has no influence at all. Three additional sliders allow you to also change the brightness, size, and color of the highlight.

Variations

The controls that I just explained allow you tremendous variation within one painting style. When you look at all the choices you have within just the Settings tab, it's mind boggling how many creative options are available. After you factor in the slider bar variations with color, lighting, and canvas, you can begin to understand the enormous number of artistic possibilities this plug-in offers.

Other Controls

Directly above the preview image, a few more controls can be found that are useful to know:

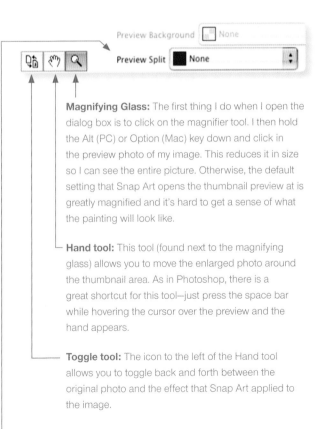

Magnifying Glass: The first thing I do when I open the dialog box is to click on the magnifier tool. I then hold the Alt (PC) or Option (Mac) key down and click in the preview photo of my image. This reduces it in size so I can see the entire picture. Otherwise, the default setting that Snap Art opens the thumbnail preview at is greatly magnified and it's hard to get a sense of what the painting will look like.

Hand tool: This tool (found next to the magnifying glass) allows you to move the enlarged photo around the thumbnail area. As in Photoshop, there is a great shortcut for this tool—just press the space bar while hovering the cursor over the preview and the hand appears.

Toggle tool: The icon to the left of the Hand tool allows you to toggle back and forth between the original photo and the effect that Snap Art applied to the image.

Preview Split: This pull-down submenu allows you to split the image in a variety of ways between the filter effect and the original photograph.

WORKING WITH LAYERS

When you click the Basic tab, the first item you see is a checkbox labeled Create Output in New Layer Above Current **(FIGURE 5)**. If you check this box, Snap Art applies its painterly magic to the image as a new layer, one which will appear above the original layer in the Layers palette. This action allows you to combine the two layers in different ways. One of my favorite techniques is to use the blend modes in Photoshop to abstract the photograph in ways that go beyond what the plug-in does on its own.

In the Layers palette, there is a pull-down menu where you see the word Normal, and all of the blend modes can be found here. Each one produces different results as Photoshop blends the painterly layer with the underlying original photo. Some of the blends won't look good while others will be incredible—experimenting is the key to getting the right look. As you scroll down through the list, you'll want to explore all the possibilities. In addition to simply blending the two images, you can also change the opacity of the filtered layer to reveal some of the underlying detail of the photo through the abstraction of the painting.

PHOTOS A and **B** show an original photo and an Impasto-style painting created from the original. **PHOTOS C, D,** and **E** illustrate how varied different blend modes can make this combination appear. Your results will not look exactly the same because there are so many parameters that come into play, such as the painting style, lighting, contrast, and the original colors, but try them out and see what styles are appealing.

FIGURE 5
Check the Create Output in New Layers Above Current box to make sure the filter is added as a new layer in Photoshop.

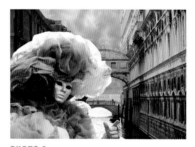

PHOTO A
The original photo of a costumed participant in Carnival in Venice.

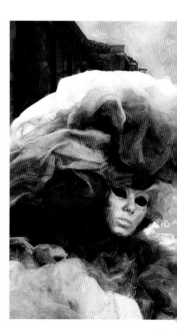

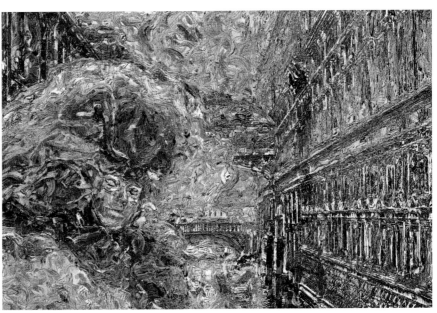

PHOTO B

The original photo with impasto-style painting layer.

PHOTO C

Blend mode "Difference" applied to painting layer.

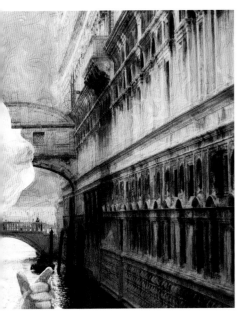

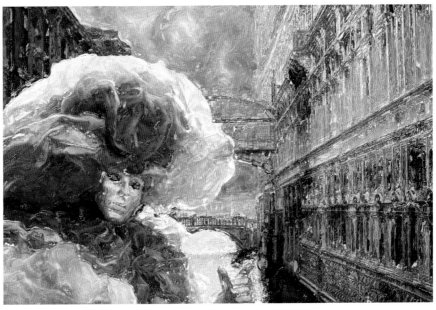

PHOTO D

Blend mode "Overlay" applied to painting layer.

PHOTO E

Blend mode "Hard Light" applied to painting layer.

SNAP ART STYLES

Charcoal

Stylize

Pencil sketch

Pointillism

Oil painting

Watercolor

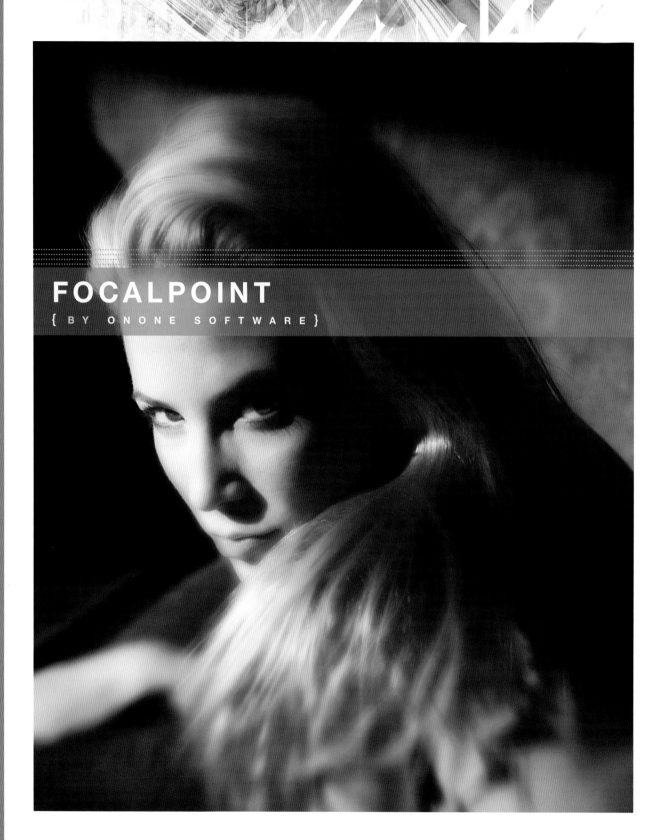

FOCALPOINT

{ BY ONONE SOFTWARE }

Creating camera blur or selective focus is a fascinating aspect of creative photography. Selective focus is a technique that allows you to virtually eliminate distracting backgrounds or foregrounds and focus the viewer's attention on the subject. Using the FocalPoint plug-in, altering the selective focus is extremely simple—it lets you put the focus anywhere in your images, and you control the density of the blur, the size, and the way the blurred portion blends with the adjacent sharp areas. Using this plug-in can transform images so they appear captured with a professional eye for depth of field and camera blur.

FEATURES

FocalPoint has a few unique features that makes it a very competent plug-in for changing the focus in your photos. In addition to simply adding blur to a foreground or background, you can vary the type of blur style that you want. For example, you can use a standard de-focused look or add motion blur to simulate panning the camera with a fast-moving subject. You can also increase or decrease the feather of the blur across a plane. Generating these effects in Photoshop without this plug-in would be incredibly time consuming.

FocalPoint can also add a vignette to the edge of your image. You have a choice of lightening or darkening the periphery as well as deciding on how the vignette blends into the central part of the image. This is one way to eliminate distracting elements around a subject.

So users could make their changes in real time, OnOne designed a unique control called a Focus Bug, which is an interactive control that makes you feel like you are adjusting your lens right inside Photoshop **(FIGURE 1)**. By moving the controls (which look like the skinny legs of a bug) with a simple click and drag, you can change the area defined by sharp focus and watch the relationship between the sharp and blurred parts of the picture continually change. Once you have an effect you like, you can save all of the settings as a preset and apply it to similar images again.

FIGURE 1
The Focus Bug makes it easy to change the focus and other settings.

NEED TO KNOW

Website: ononesoftware.com

Price Range: $ $ $ $ ○

Notes: Sometimes installing this software yields unexpected results. The plug-in may display in the Photoshop menu bar if you don't see it in the filter menu.

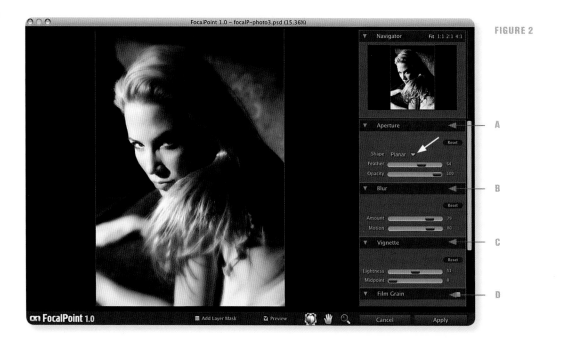

FIGURE 2

FOCALPOINT CONTROLS

To access the plug-in, go to Filters>onOne> FocalPoint. Opening the software can take a few moments because it has to generate blurs kept in its memory. Once open, the dialog box is large; the controls appear on the right side and the generous preview window displays images on the left (FIGURE 2). On the top-right side is the navigator window that displays an overview of the entire image along with a red box marking the area displayed in the preview window (this is very much like the navigator window built in Photoshop).

The Aperture box (A) is where you can choose the shape of your blur. You can choose between Round or Planar types of blurs when you click the triangle next to the word Shape (see the white arrow in FIGURE 2). The Planar simulates a tilt-shift appearance similar to what you would get in a

view camera or with a tilt shift lens. It gives a sharp slice that cuts through the image from one side to another. The Round option creates a round or oblong sharp area that is similar to using selective focus. This box is also where the Feather and Opacity sliders for the blur are found. Feather determines how smooth the transition between the blurred and sharp areas are, while Opacity affects the strength at which the blur is displayed.

The Blur box (B) contains the sliders that control the Amount and the Motion appearance of the blur for your image. It allows you to vary the blur style that is used. You can select from a standard defocused look, or add a little motion to simulate the look of certain types of lenses.

The Vignette box (C) contains controls for the amount and brightness of the vignette. It is here that you can make your photo fade to white or

FIGURE 3 The FocalPoint Toolbar E F G H I

fade to black. It lets you lighten or darken the edges of the image to minimize distractions and focus the attention back to the subject. The Midpoint slider controls the size of the vignette, while the **Film Grain slider (D)** controls the addition of simulated film grain. The last box holds presets that you might have previously saved.

Along the bottom of the main window is the Toolbar **(FIGURE 3)** and it contains the **Add Layer Mask button (E)**, the **Preview on/off toggle button (F)** and the **Focus Bug icon (G)**. It also includes the **Hand tool (H)** for navigating the image and the **Zoom tool (I)**.

USING THE FOCUS BUG

All of the slider controls just covered work very well, but you will probably be using the Focus Bug inside the preview window most of the time. The Focus Bug controls the size, position, and shape of the sharply-focused portion of the image using the antennae-like legs that point out from the center shape. The Focus Bug's antennae also adjust the controls from the Aperture and Blur panes. To better understand, take a close look at the Focus Bug's antennae; note how some of the circles at the ends are solid white (see the arrows in **FIGURE 4**) and some are empty. The solid white antennae control the size and angle of the blur that will be applied to the photo. The two empty circles each manipulate different sliders from the control panel. One changes the Amount of the blur and the intensity of the Feather effect. When you lengthen this antenna by clicking and pulling on it, the Amount of the blur increases; when you move the antenna up or down towards the vertical or horizontal axis, the Feather amount is modified. As you make these changes, watch the sliders move correspondingly in the control panel at right and it will all begin to make sense. The second empty antenna controls the Opacity and the Motion of the blur effect. Lengthen this antenna and the Opacity increases; move the antenna up or down towards either axis, and the Motion effect is changed.

FIGURE 4

Use the Focal Bug's antennae to adjust the image. The white circles control the size and angle of the blur.

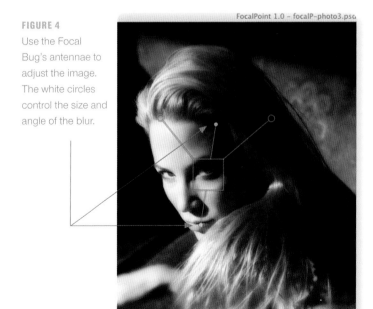

FocalPoint 1.0 - focalP-photo3.psd

Though it might be a little confusing at first, using the Focus Bug is an easily mastered interactive control that has most of the program's controls built into it.

As you begin to move the Focus Bug icon around the preview image, you will see parts of the image getting soft and blurred while the part underneath the Focus Bug remains sharp. As you move each antenna, you will see more of your image go in or out of focus as the size of the grid becomes larger or smaller. You can change from normal to soft blur to motion blur by changing the angle of the right and left antennae. If you find the grid distracting as you work **(FIGURE 5)**, it can be turned off in the top menu under View>Focus Bug Grid.

To gain a better understanding of how the blurring works, you can preview the mask being applied to the image. Go to the View pull-down menu and select Show/Hide Mask. (You can also use the shortcut: Command/Control M to view and hide the mask.) **FIGURE 6** is an example of how the mask preview would look if you were using a round blur. The black part of the image in the mask shows what will stay in focus and the white part of the image shows what is being blurred.

PHOTO A
The focus in this image has been centered on the glove using the Round aperture.

CREATING BLUR EFFECTS

To create **PHOTO A,** I chose the Round shape in the Aperture pane. The Aperture pane allows you to change the shape of the "sweet spot"—the area of the image that is sharp. It can be round, oblong, or more of a long, softened rectangle. I set both the Opacity and the Blur Amount to 100. I chose 44 for the Motion slider. When I liked what I saw in the dialog box, I hit Apply to see the finished image. The focus on this image is now on the glove of the cowboy with the rest of the image blending into a beautiful soft blur.

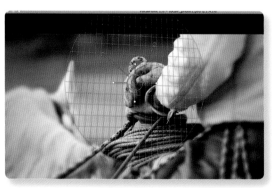

FIGURE 5

FIGURE 6
The mask preview reveals the size, shape, and feather of the focused area.

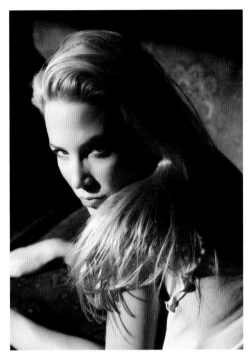

PHOTO B

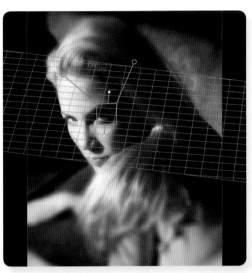

FIGURE 7

For working on **PHOTO B,** I chose to use the Planar aperture shape instead of the Round one. This changed the round circle of the Focus Bug to a square. This also reduced the four width, height, and angle antennae down to only two because a plane is just two-dimensional. I positioned the Focus Bug over the model's face and with the grid turned on, it was very easy to see the plane of focus **(FIGURE 7).** I turned the grid to a slight angle to keep the plane of focus above and below her face. This kept her face sharp while the rest of the image transitions into a gradual blur. I hit OK, and the result is a nice planar blur across the subject's face that accents her eyes while the rest of the image blends into a nice out-of-focus look **(PHOTO C).**

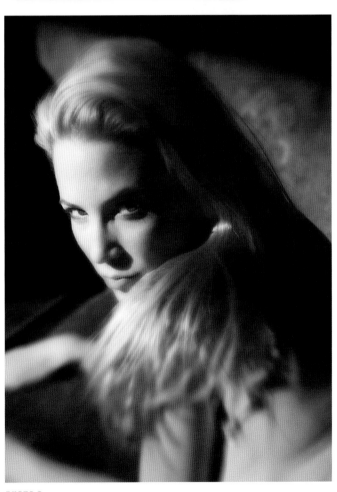

PHOTO C

Using the Planar aperture, I set the focus on the subject's face so it would stand out sharply from the rest of the image.

131

This plug-in also works great on photographs of flowers and landscapes. In **PHOTO D,** although I shot the image with an aperture of f/3.5, I wanted to add more background blur. I chose the Round aperture in the dialog box and placed the grid just around the large daisy in the foreground. FocalPoint added blurring in front of the main flower, to the sides, and also in the background. It now looks as though I shot the image with an even larger aperture **(PHOTO E).**

On the image of the white horses of the Camargue in southern France **(PHOTO F),** I wanted to make one of the horses stand out by keeping his head in focus and making everything else in the image blurred. I placed the round aperture over the horse, making sure to cover just the area I wanted to keep in focus. Leaving the grid on so

PHOTO D

Adding a background blur works great on close-ups (below) and landscapes.

PHOTO F

FIGURE 8

PHOTO E

that I could see how much of the horse was staying sharp, I kept the Opacity at 100 and also feathered it at 100. **FIGURE 8** shows where I had the round aperture positioned and also how my sliders were set for this image. The resulting image, **PHOTO G,** shows the horse's head in focus and the nice blur over the rest of the image.

FocalPoint has some of the best support for any software I have used. There is an incredible help menu, additional support on the onOne website, and great tutorial videos under the Show Me How pull-down in the menu bar. With all of these reference tools, users can really learn to get the most out of the software.

PHOTO G
By leaving just a small part of the image in focus, everything else in the picture falls away and the viewers' eyes are drawn to the horse's face.

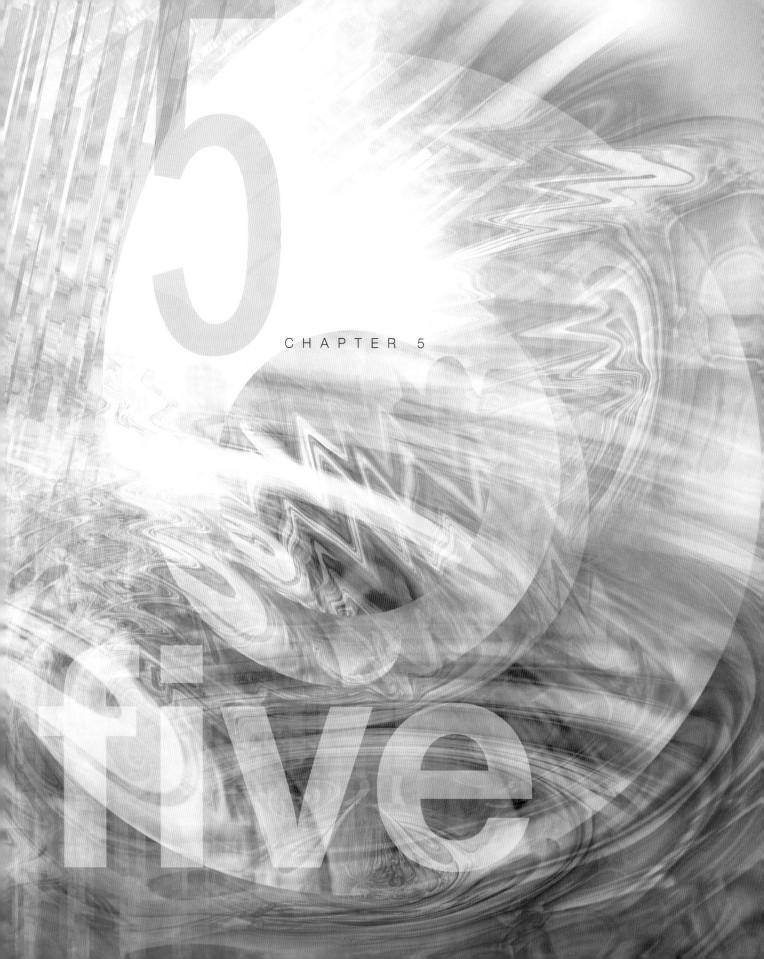

CHAPTER 5

Helicon Focus, p136 Lighting Effects, p144 Dfx, p150

INFINITY AND BEYOND

Many of the plug-ins in this book will expand your horizons and introduce you to new ways of thinking about and working on your images. Of all of them, Helicon Focus really stands out—it's almost too good to be true. This plug-in revolutionizes depth of field by allowing photographers to get complete depth of field at any lens aperture with long telephoto lenses as well as tiny macro subjects, no matter the magnification. It seems to defy the laws of physics and you may feel like it's warped your reality a bit because, suddenly, the physical limitations photographers have lived with forever concerning depth of field have been erased.

The Lighting Effects filter in Photoshop can totally dramatize a subject since it can add one or more lights to a scene and alter the color, intensity, and angle of coverage of those lights. It can also change the ratio of the added light to the ambient light in the background, making it a powerful tool for adding extra emphasis to specific areas of a photograph.

For photographers who loved using lens filters in the past, Tiffen Dfx is a great plug-in made by the company famous for its high-quality glass filters. This Digital Filter Suite, as Tiffen calls it, offers a host of technical and creative filters. One of the most valuable, named Light, creates lighting effects that studio photographers use when they project the light patterns of window panes, arches, and leveler blinds behind models or products. What used to take thousands of dollars in studio equipment and hours in prep time can now be recreated quickly with Dfx.

HELICON FOCUS

{ BY HELICONSOFT }

Helicon Focus is a fantastic program that was originally designed for macro photography, but it can also be applied to other types of images, such as landscapes, gardens, still-life photography, and even architecture. This program addresses the problem that photographers have always faced concerning the extremely shallow depth of field associated with macro work and the use of telephoto lenses. The principle upon which this plug-in is based is simple (and brilliant): Take several shots that focus on different planes throughout the depth of the image, and then use the software to combine them. The resulting photograph uses only the sharply focused parts of each photo so the resulting composite has complete depth of field.

that you want to appear sharp. For the next photos, focus a little closer to the camera for each picture until you have taken enough to cover the entire composition. As you focus on the elements very close to the lens, you will need to take more shots because the focus changes so quickly. When you have taken anywhere from six to ten pictures (some subjects may need even more—in one insect close-up I used 20 frames), Helicon Focus will merge them into a single photograph with complete depth of field. This is much more effective than using a small lens aperture like f/22 or f/32 and only taking one picture, because even a small aperture has limitations in what it can hold in focus. Taking several images and merging them with Helicon Focus means there are no limits to the kind of depth of field you can get.

GET PERFECT DEPTH OF FIELD

This type of macro or telephoto photography must be done from a tripod, and it's essential that the subject doesn't move at all from frame to frame. Once you have selected a subject, start by focusing on the farthest point in the composition

I usually use f/8 because that is the "sweet spot"—typically, it's the sharpest f/stop in a lens. You could use a larger lens aperture if necessary and get equally good results while using Helicon Focus. It is indeed remarkable to get a completely sharp picture from front to rear with a long lens or with a macro setup when the lens aperture is only f/8.

NEED TO KNOW

Website: heliconsoft.com

Price Range: Free (with some limitations)

Notes: Helicon Focus is shareware, which means it's free; however, after 30 days, promotional text will be added to images modified by the software. See the website for more details.

Compare **PHOTOS A** and **B** that were taken in a historic Confederate cemetery in Tennessee. **PHOTO A** was taken with a 200mm lens at f/8 where I focused on the background. This is just one of the images that was merged to form **PHOTO B.** You can see how shallow the depth of field is. Had I closed down to f/32, I would definitely have had more depth of field, but because I was close to the large headstone in the foreground (I was about twelve feet away), there is no way that I could have gotten the entire frame tack sharp. With the help of Helicon Focus, the grass in front of the large headstone is tack sharp and the most distant grave markers and leaves in the background are also crisp. I used twelve different images to accomplish this effect, six of which can be seen in the following series.

PHOTO A

These six images were taken with a tripod, and in each picture I set the focus plane a little closer to the camera. By combining them in Helicon Focus (with six other pictures that were part of this series), I was able to get a final image (photo B) with complete depth of field.

PHOTO B

A series of photos merged by Helicon Focus created this one sharp image with complete depth of field.

Macro Photography

Helicon Focus excels in macro photography.
When it is impossible to hold focus on a small
subject from front to back, even at the smallest
lens aperture, you can shoot it several times and
assemble the images into one composite image,
allowing you to accomplish what photographers
have always wanted to do—defy the laws of optics
and achieve complete depth of field. Compare
PHOTOS C and **D.** Both of these pictures were taken
at f/22. I used a 200mm lens plus an extension
tube that turned my lens into a telephoto macro.
The depth of field inherent in this kind of lens setup
is extremely shallow; so shallow in fact, that even
at f/22 much of the piranha (which was mounted
on a stand) in **PHOTO C** is out of focus. Compare
how tack sharp **PHOTO D** is from the teeth to the tail.
You can see the same thing in the two shots of an
orchid in **PHOTOS E** and **F.** In **PHOTO E,** I used f/32
because the structure in the middle of the flower
protruded about 3/4-inch away from the petals.

PHOTO C

PHOTO D
Even macro subjects can be shot with complete depth of field.

However, it's not as sharp as **PHOTO F,** where I
used ten different images that were assembled
in Helicon Focus. Notice that every petal is
sharp in addition to the central structure. I
purposely kept the background out of focus.

PHOTO F

PHOTO E

USING THE SOFTWARE

Like virtually all software, Helicon Focus has many options. However, if you use the default choices you can run the program with extreme ease. In fact, for the complexity of what it does, it's almost comical how easy this software is to use.

When you launch the software, a dialog box opens; in the upper-left corner there is an Open icon. Click this icon and browse for the images you want to merge. It is easiest to place them in a single folder on your desktop ahead of time so they can be located quickly, and then select the individual images rather than the folder itself.

Before you put the images in the folder, make sure that:

1. They are identical in size and exposure.

2. They were taken from a tripod and that you either used a cable release or the 10-second self-timer on the camera to prevent any movement during the exposure. It's also a good idea to use the mirror-lockup feature on your camera; this further eliminates any possible source of movement during image capture. Many times you can get away without this kind of meticulous work, but I like the odds to be in my favor for getting the most out of this technique.

3. No part of the subject or the scene moved during the various exposures.

When you select the images in the folder, they will appear in a column on the left side of the dialog box. At the same time, a large preview window shows one of the images in the list. In **FIGURE 1**, you can see an image of a weevil crawling over bark. Notice the slice of this image that is in focus—it is a narrow portion of the bark behind the insect. In each image of the weevil, a narrow portion of the image is in focus like this. When they are all combined, the result is complete depth of field throughout the photo. Once your series of images are showing in the dialog box, all you have to do is click the cog-shaped icon at the top labeled Run (see the red arrow in **FIGURE 1**). And that's it; there's no need to mess with lots of settings or controls.

FIGURE 1
Press the Run button to start the photo merging process.

PHOTO G
Helicon Focus allows you to choose what parts of the image will stay in focus.

Helicon Focus will assemble all the photos into one composite, and if you were meticulous in your shooting, the resulting image will be astonishing. This is something that could never before be accomplished in photography. **PHOTO G** shows the result of the weevil composite, where the entire image is sharp except where I decided to leave the background out of focus. When finished, the composite image can be saved as a Photoshop file to your desktop. I always save images to the desktop so I can find them easily and file them where they belong.

PHOTO H

ADVANTAGES OF HELICON FOCUS OVER f/32

There are several advantages to choosing Helicon Focus over your smallest lens aperture. First, you can shoot at any lens aperture and still get complete depth of field. If the light is very low and you are afraid of the subject moving slightly (due to a small breeze, for example), you can shoot with a large lens aperture. As I have already mentioned, you can also choose the sharpest f/stop in the lens—the "sweet spot"—for maximum resolution.

Second, you can define exactly the amount of depth of field desired. Many times we want the background to be out of focus and the subject completely sharp. If the subject is very close to the background, such as an insect in front of leaves, a small aperture will not only get the insect sharp, but the background elements will be clearly defined as well. This is often undesirable because busy backgrounds are very distracting. By defining how many slices you focus on throughout the composition, you can keep the background nicely blurred but still render the subject sharp. Look at **PHOTO H** as an example. Note how sharp the katydid and the flower are while the background remains artistically soft. Similarly, in **PHOTO I,** the wasp nest is completely sharp, including the eggs inside the recessed sacs, but the background is out of focus and doesn't distract from the subject.

PHOTO I

Now compare the two shots of a rhinoceros beetle in **PHOTOS J** and **K. PHOTO J** was taken with a lens aperture of f/32. Notice how defined the leaf is behind the insect? In **PHOTO K,** the leaf is much softer. That's because I used f/8 for this Helicon Focus composite, and while the entire insect is as sharp as possible, I didn't include focused images of the leaf in the series that made the final image. Therefore, it remained out of focus and does not distract from the beetle.

PHOTO J

PHOTO K

PHOTO L
Get the benefits of compression and complete depth of field using Helicon Focus.

The third advantage of Helicon Focus is you can enjoy the compression of elements in a scene characteristic of telephoto lenses and still have complete depth of field. Look at **PHOTO L**, taken in the incredible Keukenhof Gardens in Holland. You can see that a long lens was used, and because I was relatively close to the foreground, it would

have been impossible to get the entire area of the composition in focus even at a small lens aperture because telephotos have such shallow depth of field. Helicon Focus made it possible, however, to have complete depth of field and at the same time achieve compression in the image.

LIGHTING EFFECTS

{ BY ADOBE }

There are only two native Photoshop plug-in filters discussed in this book. One of them is Liquify and the other is Lighting Effects; the latter is a plug-in that I feel is so useful, and so different from the others, that it is too important to ignore. The Lighting Effects filter does not do what many users first think, which is change the direction of light in a scene. In other words, you can't make a landscape shot taken at noon look like a sunrise or sunset. What Lighting Effects can do is place a spotlight or a beam of light from one or more light sources on your scene to focus attention on an area and add a dramatic type of contrast. If you apply these additional light sources to the right kind of subject, it can look completely natural with no hint of digital manipulation. For example, a spotlight applied to an indoor portrait can look entirely appropriate. If you use the same kind of effect on a beach scene, however, it would look unnatural—so choose your images wisely.

NEED TO KNOW

Website: adobe.com

Price Range: Free (included with Photoshop)

Notes: This filter only works on RGB files, so pictures saved as gray-scale, duotone, lab files, and CMYK can't use Lighting Effects. If you have a black-and-white shot, convert it to an RGB file using Image>Mode >RGB.

CHOOSING THE TYPE OF LIGHT

Access the Lighting Effects filter in the Photoshop dropdown menu Filter>Render>Lighting Effects. This opens the filter's dialog box **(FIGURE 1)** where there are two pull-down submenus, Style and Light Type, where you can choose the type of lighting. The Style menu has options for choosing a variety of light and I go into more detail on these choices in a moment. It helps to first understand the workings of the Light Types pull-down menu before choosing a Style, so we'll start there.

The three options under the Light Type pull-down menu are:

Omni: This shines the light in all directions from directly above the image, simulating the way a light bulb would look shining over a piece of paper.

Directional: This point source of light simulates the sun in that it is far away. Because of this, the angle of light as it is seen in the photo will appear to be the same anywhere it is moved.

Spotlight: This type of light casts an elliptical beam. The line seen in the preview window defines the light angle and direction, and you can drag the handles on the edges of the ellipse to define its shape.

FIGURE 1

Change the look of light in your images using the Style and Light Type Menus.

Depending on which type of light you select, a straight line or a circular outline (denoted by the red arrow in **FIGURE 2**) will appear over the preview image in the left side of the dialog box. This shape defines the form of the spotlight or the beam of light that spreads across the photo. Inside this outline is a white dot, and by grabbing and moving it, you can place the center of the light anywhere in the image. On the edges of the circular outlines are small square handles, which can be pulled so the beam or spot of light changes shape. You can make a beam of light narrower or wider depending on the effect you want. You can also re-orient the way the light shines on your photo by flipping the light source 180˚ by grabbing the handles and physically moving the direction of the light so it comes from the opposite side.

Multiple Lights

If you want to duplicate a light you have already added, you can hold down the Alt key (PC) or the Option key (Mac) and pull that center white dot to another point in the image to copy it. Another light source instantly appears, identical to the first, and it can be placed anywhere in the image. You can also drag the light icon at the bottom of the preview window onto the photo to create more lights, though they won't be exact duplicates of an already existing light. You can see the effect of using multiple lights in **PHOTOS A** and **B.** In **PHOTO B,** I illuminated the two costumed people with a spotlight on each of their masks, and this added drama to the image, almost as if I had used actual studio lighting, specifically grid spots. Up to 16 lights can be added to an image and, if need be, they can be deleted one-by-one by dragging them to the small trashcan.

FIGURE 2

PHOTO A
This original picture has no lighting effects applied.

PHOTO B
Two spotlights were added to highlight the masks.

ADJUSTING THE EXPOSURE

There are four sliders in the dialog box that are essential for changing the exposure and the look of the light. They are Intensity, Exposure, Focus, and Ambience. You have control over both the digital light being added as well as the ambient light, which is the exposure already in the rest of the image. In other words, you can vary the spotlights and any beams you add independently of the background and independently of each other. As you experiment with these four sliders, you will quickly see how they affect the image and offer creative options for modifying the lighting on your subjects.

Study **PHOTOS C, D,** and **E,** which show another image from Carnival in Venice. By manipulating three sliders—Exposure, Intensity, and Ambience—the relationship between the spotlight and the ambient light changed. The Ambience slider had the largest impact on this portrait because it allowed the area around the center of the spot light to be seen or to be suppressed by shadow. In **PHOTO D,** you can see that the exposure in the center is lighter than the surrounding area, but the periphery is still vignetted to a certain degree. In **PHOTO E,** I moved the Ambience slider to the left and the entire frame became considerably darker except for the center of the mask. You can see this happen in real time in the thumbnail image as you work. The lighting Style used to achieve this look is called Flashlight (again, we'll review Styles in a moment).

One issue to pay close attention to when applying additional lights is how bright the highlights become. In the portrait seen in **PHOTOS C** through **E,** the mask is very light. As the exposure or intensity sliders are moved, it is very easy to blow out the detail in subjects like this. Blown highlights—meaning a complete loss of detail and texture in the highlights—are the last thing you want in any photograph. The preview thumbnail in the Lighting Effects dialog box is small, so you have to watch the changes in your image carefully to make sure you protect the highlights. The most common mistake I see in digital manipulation is too much contrast gain, and along with that comes the expected loss of highlight detail.

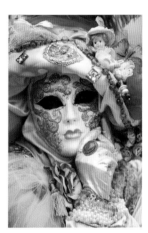

PHOTO C

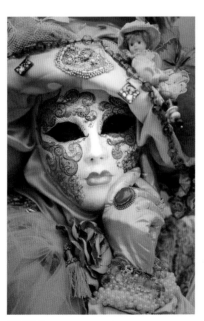

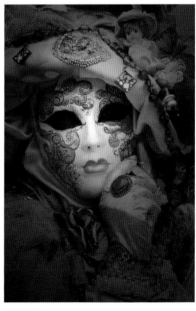

PHOTO D

PHOTO E

LIGHTING STYLES

The real power of the Lighting Effects filter lies in the Style pull-down menu. You can introduce spotlights, colored lights, shafts of light streaking across the image, and multiple lights shining either up or down. One of my favorite examples of using multiple lights can be seen in **PHOTO F.** Michelangelo's famous statue of David in Florence, Italy is, in reality, lit solely by daylight coming in from the dome above—there are no spotlights on the wall behind the statue. Yet by choosing Three Down under the Style menu, I was able to give the image a completely different lighting look.

PHOTO G
The Crossing Light style changed this outdoor photo into a studio-style shot.

PHOTO F
Add multiple spotlights using the Three Down option in the Style menu.

In **PHOTO G,** I used a different style of light called Crossing. I used the Ambience and Intensity sliders to darken the environment, and by adding that one digital beam of artificial illumination, I turned an outdoor photo taken in San Marco Square in Venice into what looks like a studio portrait.

I took a different approach in creating the lighting on the tulip in **PHOTO H.** Here I used the Soft Omni light, but I duplicated it four times **(SEE FIGURE 3)** by holding down the Alt (PC) or Option (Mac) key and dragging it to various places in the image three times. I also pushed the handles inward to reduce the size of the light so I could create small, localized hotspots on the petals of the flower. To create an effect like this in a studio would take very expensive

PHOTO H

The Soft Omni style created small hotspots that highlight the flower's petals.

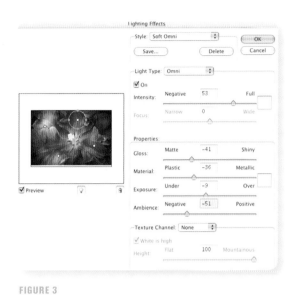

FIGURE 3

The Lighting Styles dialog box offers many controls for setting the exact mood for an image.

equipment and several hours to set up, but I did this example in less than one minute. What took the most time was deciding precisely where and what size the lights should be.

Using the same technique with the same type of lighting, look at the remarkable difference I was able to make in the Philadelphia skyline in **PHOTOS I** and **J.** I introduced five points of light that add to the beautiful twilight illumination, and now there is a unique interplay of highlights and shadows that was not there before.

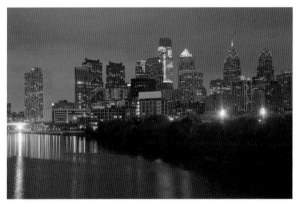

PHOTO I

PHOTO J

The Soft Omni style was used again to add dramatic lighting to this skyline.

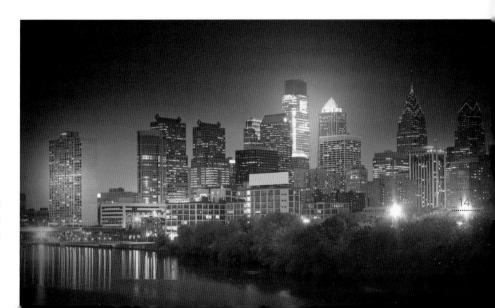

DFX
{ BY TIFFEN }

Tiffen, the company best known for making outstanding glass filters for camera lenses, has created a very unique set of Photoshop plug-in filters named Dfx. The effects that you can create in this plug-in are impressive; with eight main filter categories displaying numerous sub-filters, this expansive plug-in offers photographers a wide range of photo effects, from color-processing, to film lab techniques, to a host of interesting effects that no other plug-in offers. One of the best, which will be covered here in detail, duplicates lighting effects that could previously only be accomplished in a professional studio. With Tiffen Dfx, it's easy to lose track of time and spend hours developing variations for individual images that can then be saved as favorite presets.

NEED TO KNOW

Website: tiffen.com

Price Range: $ $ ◯ ◯ ◯

Notes: The trial software is active for a 15-day period. To find the demo download, go to the tiffen.com homepage>Dfx Software link> Dfx v1 Downloads link.

OVERVIEW

In creating this unique plug-in, Tiffen has taken a departure from what it has traditionally been known for, which is high-quality glass filters. This digital filter suite does simulate various types of effects that can be accomplished with lens filters, such as colored gels, adding a gold reflector look, vignetting, star effects, and various types of diffusion, but it gives you an infinite ability to tweak each of these effects. In addition, the suite of filters has lighting effects that I have not seen from other software manufacturers. Unique to the Tiffen set is the ability to project light patterns from windows, arches, and other architectural shapes. In the past, studio photographers spent a lot of money to build sets for this very purpose. Now the same effects are available without spending thousands of dollars and investing considerable time. **PHOTO A** is an example where I added a pattern of the shutter's light over a model. At the opposite end of Dfx's spectrum, you have the capability of introducing surrealism into your images, such as in **PHOTO B.**

PHOTO A
Add studio-style lights to pictures using Dfx.

PHOTO B
Get experimental with Dfx's variety of creative filters.

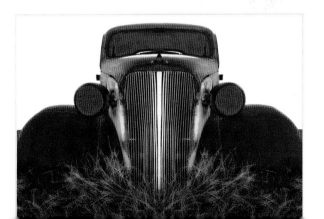

Dfx can be bought as either a Photoshop plug-in or as a stand-alone program. The complete stand-alone program has more features, such as batch processing and very nice masking tools, but the plug-in for Photoshop is filled with an incredible amount of filters. If you are working on many files and want to batch apply similar effects, then the stand-alone application might be the best option for you. If you are mainly working on individual files, I think the plug-in filter might be the way to go.

THE DFX INTERFACE

When you first open Dfx, the impressive interface with its many options can be overwhelming for a moment **(FIGURE 1).** But don't worry; the program is very simple to use after just a few minutes of familiarizing yourself with it. The workspace is somewhat customizable, so you can drag the dividers on either side or the bottom of the dialog box in order to resize the windows as you see fit for your working style.

Let's take a quick look at how the Dfx dialog box is arranged. The main categories appear in the tabbed Filters palette **(A)** at the bottom of the screen. The Presets palette **(B)** appears on the left, while the Parameters palette **(C)** can be accessed on the right.

The Presets palette displays thumbnails of the many styles available for the filter type you chose.

FIGURE 1

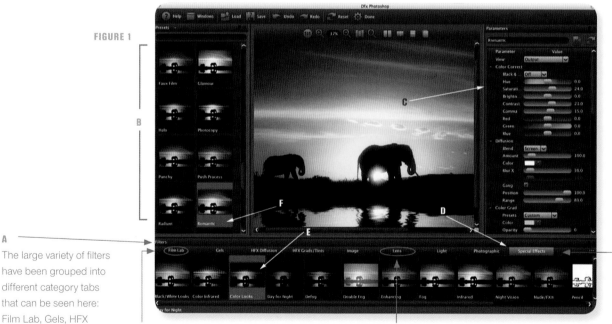

A
The large variety of filters have been grouped into different category tabs that can be seen here: Film Lab, Gels, HFX Diffusion, HFX Grads/Tints, Image, Lens, Light, Photographic, and Special Effects.

Under the Film Lab tab, you will find presets such as Cross Processing, Bleach Bypass, and Grain.

Under the Lens category, you will find presets for Depth of Field, Lens Distortion, and Vignette.

Under the Special Effects category tab, you will find presets for Infrared, Night Vision, and X-Ray.

For example, if you opened Dfx, selected the Film Lab tab from the Filters palette, then chose the Flashing filter option, you will see all of the pre-programmed style options available in the Presets palette. After selecting one of these choices, going to the Parameters tab gives you access to all of the slider controls that can further modify this preset. If you make a lot of tweaks to a preset style, you can save it as a new preset (the steps for this will be covered in the next section). This is just a basic overview of the interface. We'll see how it works in practice as we next begin working on some images.

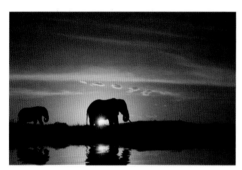

PHOTO C

WORKING WITH DFX

One of the most important factors in working with any kind of plug-in is choosing the right images to manipulate. The photo of two elephants in silhouette at sunrise (PHOTO C) is a strong graphic shot with excellent color. Although the photo is very strong already, using filters from Tiffen Dfx will give this image an improved look.

To start, I chose the Special Effects category (D) from the Filters palette (FIGURE 1). From the options available under that tab, I can choose from Black/White Looks, Color Infrared, Color Looks, Day for Night, X-Ray, Night Vision, Polarizer, and more.

I chose the Color Looks filter (E), which gave me a whole new set of options in the Presets palette. After looking through them, I chose the Romantic preset (F) and then clicked the Parameters tab. After reviewing them, I left the parameters at the default setting and hit OK; the resulting image, PHOTO D, has much more color and vibrancy than the original.

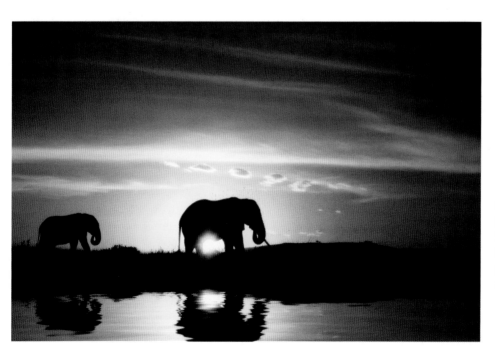

PHOTO D
By using the Color Looks filter and modifying it with the Romantic preset, this picture was livened up with brighter colors.

PHOTO E was taken inside a church in France. I wanted to give it a sepia-toned look, so I once again chose the Special Effects category **(FIGURE 2, A)**. This time I chose the Black/White Looks filter. I scrolled through the Presets styles and chose Still Life 1 **(B)**. Although I like the way Still Life 1 looks, I decided to lighten up the image a little more with the brightness slider in the Parameters window.

The shadows were still a little too blocked up so I also chose to decrease the contrast to -37.5 **(C)**. This gave me a much better overall look and the exact feeling that I was going for. The image is now halfway between a nice sepia tone and a deep, rich black-and-white image with a nice, old-fashioned look **(PHOTO F)**.

PHOTO E

PHOTO F
I gave this picture an old-fashioned feel by using the Special Effects category's Black/White Looks filter combined with the Still Life 1 preset.

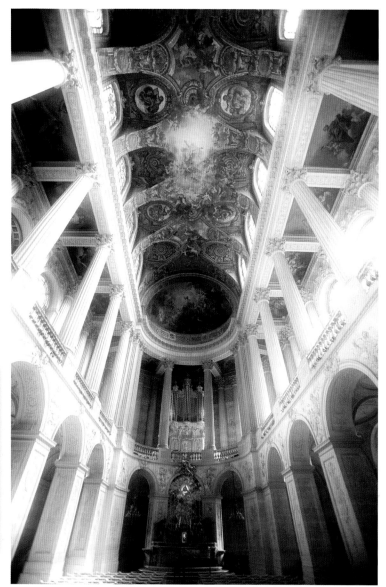

A

B

C

FIGURE 2

Saving Presets

Once the parameters have been changed, they can be saved as a new preset. To do so, type in a new name where the old name appears at the top of the parameters palette. For example, I was using Still Life 1, and I just clicked on the name and typed in my new one, which was "Church Sepia Paris" **(FIGURE 3, A).** Now click the Add Preset button **(B),** which is right next to the window where you gave your preset a new name. Instantly, the new preset shows up with a new icon at the bottom of the Presets palette. This is without a doubt one of the best features of this plug-in.

Preview Settings

Another feature Dfx excels at is the preview; depending on the style chosen, it can display four options of before-and-after or side-by-side comparisons. There are four icons above the main preview window; the far right icon will show a complete before and after preview if selected. **FIGURE 4** shows the split screen before-and-after display—the before image appears on the bottom and the after image appears on top. This is a great way to see if you like what you've done or if you need to make further changes.

FIGURE 3

FIGURE 4
The Dfx split-screen preview.

BEST FILTERS

There are many great filters and presets to experiment with in this expansive plug-in. However, some stand out more than others. The following are a couple of my favorites that deserve extra attention.

Light

One of the most interesting filters in the Dfx collection is called Light, which is designed to simulate the effect of projecting light and shadow onto a background. It is similar to using a Gobo in photographic terms, and the results that you can obtain from this particular category are unlike any other filter I have ever seen. Using this plug-in, patterned light can be added to a scene where none existed before, just as if you were adding light at the time of shooting. Some of the presets include Shutters, Venetian Blinds, French Doors, Church Windows, Spot Lights, Fences, Palm Trees, Clouds, and over 500 others. Some of these effects look much more realistic than others; you should experiment to see which ones appeal to you.

155

PHOTO G shows a composition that has plenty of open space on the left. This negative space is perfect for using the Light filter. I wanted to make it look as though the subject had been photographed with light from French doors cast behind her. The Light category tab gives you ten filters to choose from; the one that offers the effect I wanted is also called Light. Once you choose the Light filter, the left side of the dialog box is filled with an incredible amount of lighting presets.

I chose the first one called French Doors. As you can see in **FIGURE 5,** the light pattern shows up in the middle of the image, right over the subject's face. It looks interesting this way, but it needs to be moved into a better position. On the corners of the photo are small little boxes (see arrows) that allow you to click and drag the shadow into a new position wherever you want it to be. In **FIGURE 5,** I pulled on the little boxes and began to position the shadow off her face into the open area on the image's left. Notice that by using the boxes, you can also change the angle of the light pattern's display. This is very useful because light cast through windows falls at different angles as the time of day changes.

When you're happy with the placement of your light pattern, go to the Parameters palette and change the Intensity, Blur, and other settings to get the pattern looking even more realistic. You can see in **PHOTO H** that the French Doors pattern looks very realistic. It would be extremely difficult to do achieve this effect in Photoshop alone.

PHOTO G

PHOTO H

FIGURE 5
Once the French Door light pattern appears, it needs to be moved and modified to work in the image.

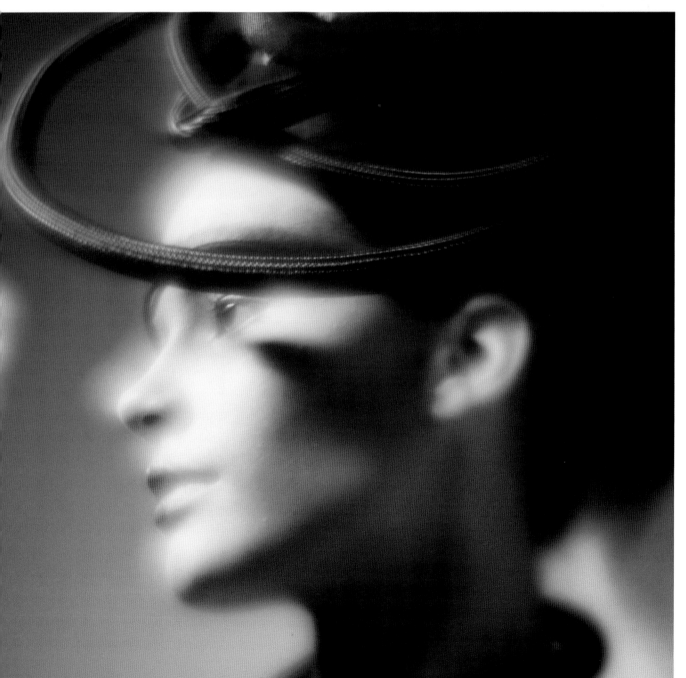

Bleach Bypass

Another unique filter within Dfx is Bleach Bypass. Bleach Bypass is a film laboratory technique where, by skipping the bleach stage in the color processing sequence, silver is retained in the image along with the color dyes. The result is a black-and-white image superimposed on a color image. Bleach Bypass images have increased contrast and reduced saturation, and they often look pastel in coloration.

For this example, I applied the effect to a picture of rickshaw in Calcultta, India **(PHOTO I).** I opened the Film Lab category and selected the Bleach Bypass filter **(FIGURE 6).** From the list of presets, I chose Bleach Bypass 2, and although I liked the way it was looking, I altered the sliders in the Parameters palette to get an even more dramatic and edgy look. I increased the Amount, Saturation, and Contrast sliders to further compound the dramatic effect **(FIGURE 7).** The resulting image, **PHOTO J,** has a completely different look than the original and is darker with more vibrancy and more contrast.

> **Note:** *If you are working on a filter and want to undo a few steps, go to Edit>Undo History. A pull-down menu will appear from which you can select the step you'd like to return to.*

Tiffen Dfx has an extensive built-in Help menu that is easy to use and explains every option available. It also shows a complete list of before and after images for what each of their filters looks like, which is very useful.

Tiffen Dfx is unlike most other software available; it really offers a lot of relevant filters photographers are looking for. The enhancement to creativity and the user experience are really second-to-none, which makes this one of the top sets of filters available for Photoshop and well worth the investment.

FIGURE 6

FIGURE 7

PHOTO I

PHOTO J
Using the Bleach Bypass filter and modifying the parameters gave this image a painterly look.

INDEX